T0060082

PENGUIN BOOKS

I Paint What I Want to See

Philip Guston was born in Montreal, Quebec, in 1913, the seventh child of Russian immigrants. Raised in Los Angeles and largely self-taught, he found inspiration for his early murals in the masters of the Italian Renaissance. Early acclaim as a figurative painter and years spent teaching in the mid-West were followed by a Prix de Rome in 1948–9, after which he moved permanently to New York and turned to abstraction, joining contemporaries Pollock, De Kooning, Kline and Rothko. In the mid-1960s, Guston withdrew from the New York art scene to work on his late figurative paintings in Woodstock until his death in 1980, weeks after the opening of a major retrospective. His work and writings continue to exert a powerful influence over contemporary artists, and he is widely acknowledged as one of the most important American painters of the past century.

PHILIP GUSTON

I Paint What I
Want to See

PENGUIN BOOKS

PENGUIN BOOKS

UK | USA | Canada | Ireland | Australia
India | New Zealand | South Africa

Penguin Books is part of the Penguin Random House group of companies
whose addresses can be found at global.penguinrandomhouse.com

This collection first published 2022

010

The Acknowledgements on pp. 269–72 constitute
an extension of this copyright page

Set in 11.2/15.7 pt Haarlemmer MT Pro
Typeset by Jouve (UK), Milton Keynes
Printed and bound in Great Britain by Clays Ltd, Elcograf S.p.A.

The authorized representative in the EEA is Penguin Random House Ireland,
Morrison Chambers, 32 Nassau Street, Dublin D02 YH68

A CIP catalogue record for this book is available from the British Library

ISBN: 978–0–241–52571–5

www.greenpenguin.co.uk

CONTENTS

INTERVIEW WITH DAVID SYLVESTER
1960

PHILIP GUSTON: We were talking yesterday at the studio about the picture plane, and to me there's some mysterious element about the plane. I can't rationalize it, I can't talk about it, but I know there's an existence on this imaginary plane which holds almost all the fascination of painting for me. As a matter of fact, I think the true image only comes out when it exists on this imaginary plane. But in schools you hear everyone talk about the picture plane as a first principle. And in beginning design class, it's still labored to death. Yet I think it's one of the most mysterious and complex things to understand. I'm convinced that it's almost a key, and yet I can't talk about it; nor do I think it can be talked about. There's something very frustrating, necessary, and puzzling about this metaphysical plane that painting exists on. And I think that, when it's either eliminated or not maintained intensely, I get lost in it.

This plane exists in the other arts, anyway. Think of the poetic plane and the theater plane. And it has to do with matter. It has to do with the very matter that the thing is done in.

DAVID SYLVESTER: The matter giving a certain resistance so that we don't go straight through it to the idea?

PG: Exactly. In other words, without this resistance you would just vanish into either meaning or clarity, and who wants to vanish into clarity or meaning?

DS: But apart from this thing of the picture plane, most great paintings have this duality between the forms of the surface and the forms in depth.

PG: Exactly.

DS: There's a tendency in a lot of recent American paintings not to want to get this depth.

PG: I think that de Kooning works in depth, and it might be one reason why he's never felt the need to enlarge.

DS: I was going to say that you and de Kooning both seem to work in depth while preserving the plane.

PG: I would say so, I would say so.

DS: And is this a matter of instinct or a matter of wanting to? Well, that's a silly question . . .

PG: But, of course, you know, it's terrible to rationalize about painting because you know that, while

you're creating it, you can have all sorts of things in your mind consciously that you want to do and that really won't be done. You won't be finished until the most unexpected and surprising things happen. I find I can't compose a picture any more. I suppose I've been thinking about painting structures for many years, but I find that I know less and less about composing and yet, when the thing comes off in this old and new way at the same time, weeks later, I get it, and it arrives at a unity that I never could have predicted and foreseen or planned. And yet this is a problem that we all have dealt with.

DS: How much of a developed idea do you begin a picture with?

PG: Well, I always begin with some kind of . . . Well, I work on only one painting at a time. It goes on for weeks, sometimes months, and scraping and putting it on and scraping, as you know, and it's as if I have to save myself on that one work. And then, when it's done, God knows how, it always seems impossible to paint another picture. Utterly impossible. And when it's done, life seems wonderful again and you feel marvelous.

DS: How long does this last?

PG: It lasts about a week – two weeks would be the limit. I start paying attention to my family and go

to parties, and I think life is terrific. And then this thing starts again, and when I start again I think I have found a way, and I really like that last picture, which has become such a friend. But later it becomes a terrifying enemy because I really want to do it again. I think, 'Well, I'm a painter, I can certainly make a picture now and . . .' This has been going on for years with me and I . . . I'll start with the same elements, and why not? Other painters have made variations on paintings. It goes on like that, optimistically, for a week, and then it starts to break down again. And I always start with a kind of ideal picture in mind.

DS: Has it got a color, this ideal picture?

PG: Oh, it has some kind of a marvelous structure. It has to do with a dream about painting – you know, I'd really like to make a real great painting and I just can't do it. It really breaks down after a while and I find bit by bit, you know, I find myself getting dumber. Really, I don't know. Perhaps it's all these parties I've been going to recently, but right now I don't know what to say about painting. It always remains the most puzzling, enigmatic thing. But when this thing happens, this very peculiar and particular thing does finally happen, in other words, when you have these few lucid moments . . .

I mean you could be a carpenter, I'd say that in a month I'm a carpenter for almost thirty days and then I have three hours, four hours, when the thing happens and I wish I didn't have to be putting those planks together – putting this color on top of that color and structuring to my own increasing boredom.

DS: Do you find that the conclusion of the pictures often comes quite quickly?

PG: Yes, the last stages, very certainly. I always know when it's going to happen too. I know the day, the day you take the phone off the hook. It's when you've played all your cards, all your dice, clever tricks.

DS: When you get towards the end, do you actually foresee what it's going to look like?

PG: No.

DS: You still have to find out?

PG: I still have to find out. But I know when this happens. I mean, it's when I don't back up any-more to look; I don't put something down and pull out a cigarette and look. Someone said to me the other night something interesting. I was talking to a foreign painter I know and we were talking about 'How do you know when you've finished?' – which is a very interesting problem.

Actually it is the key to all things. When is a painting finished? And last week I had finished a painting; you saw it yesterday. I had worked around the clock for three or four days and nights; I think I got one night's sleep. I kept on and on and on. That's how I usually work, and this friend said that she'd read somewhere that Hemingway had said that he leaves his workshop when something has happened in his work that promises him something to do the next day. And I thought, 'Oh, my God, I feel just the opposite.' And yet I know that feeling. In the past I would stop when something happened on the canvas and I would think, 'Oh, yeah, tomorrow I'll work on that.' But that's like promising yourself a goodie for the next day. I think it's very adolescent. I like the early Hemingway books, but I find I can't do that. It's an immediate thing, it's a crucial moment. It's somehow a feeling of all your forces, all your feelings, somehow come together and it's got to be unloaded right then. I mean, there're no cookies for the next day at all. There is no next day.

DS: And when it's going, you really can stay there? You don't have to get away from the canvas and see how the picture looks?

PG: I don't even know that I'm doing it at that time. It's a peculiar moment to talk about. The mind being as devious as it is, you could see the whole thing as a kind of moral test, I think. And you know exactly and precisely when you're kidding yourself. It's a thirty-secondth of an inch, but, you know, the narrower it gets, the more devious it gets. We all know that. I mean, writers are like that. Actually, painting is exactly parallel to life. I mean, you know when you're really making love and when you're not really making love, or any emotional involvement. Did you ever listen to someone talk on a platform or in conversation when you knew he was only telling you a story and your mind wandered? But when you always really listen is when they are not hearing themselves tell the story. Well, that's creation. That's all it's about. And anyone who can see can see it in a painting. Don't you think so? It's only the very object of painting to get to that point, and I don't think it has anything to do with spontaneity either. And if it is freedom, it's a very peculiar kind of freedom. It's the kind of freedom that's weighed down with a lot of baggage, but it's a very necessary kind of freedom because . . .

DS: . . . it must be achieved.

9

PG: It must be achieved. Yes, but only under certain conditions.

DS: Well, I mean, the carpentry, as you call it, is the necessary preparation to – to put it rather pretentiously – the dark night of the soul.

PG: I know I've thought so too. I think that's a kind of necessary rationalization. Would you be as interested in seeing men fly, unattached and free, as you would be in seeing a man with, I don't know, two hundred pounds of cement strapped onto him and let's see him get two inches off the ground. I think creation is something like that. It's not imagination and it's not freedom and it's not spontaneity. I think it's a more human experience than that. I mean it can be tragic; it can be joyful; it's compounded of so many elements and increasingly I almost think I don't want to analyze it any more, think about it. And yet, when this thing has happened . . . Right now, for the last few days, I've been thinking: Now what in the hell happened those three days and nights I worked around the clock? What pictures did I scrape out? And then I remember the pictures I scraped out. So that I keep tracing what it is that happened. You somehow propel yourself or are propelled into a kind of open-eyed sleep or a sleep where you are acting. I don't think you can worry

yourself into this state. I think you just become that. Perhaps that's what the painting represents. Actually, one of the real problems that always bothers me is sustaining a feeling. I mean, when I look at Poussin now, well, I think that's the most incredible thing to maintain the feeling for a year, however long it took Poussin, I'm telling you, to paint this vast structure. But perhaps that is not given to us now. I don't know.

DS: Perhaps we can only make sort of fragmentary statements?

PG: I don't know. Actually, all modern art puzzles me. I don't understand it. I really don't. I don't know whether it's fragmentary. I have a sickening nostalgia for this other state of sustaining a feeling for months, being able to construct and build a picture. Well, Mondrian, I think, did that, of course. He was almost one of the last artists to do that. I wish I could get there.

DS: Going back to this other thing of creating depth in a painting. Now, when you convey a sense of space, there tends to be, whether you like it or not, a tendency for figuration to come in. I mean, the creation of depth is very much involved with the whole concept of figurative painting.

PG: Of course.

DS: I'd like to know what you feel about this whole problem of figuration. Do you want your painting to have references?

PG: Absolutely. You know in the forties I was very involved with figuration. I painted a whole series of children's pictures, all sorts of props and so on; they were always imaginary. I don't think I ever really painted much from life, although I have done several portraits. But these pictures were imaginary, and even though I used scenes, houses and figures and tables, chairs, wooden floors, things, instruments, there too I wanted to get to a point where the burden of things didn't exist and something else came through. You use things; the idea is, of course, to eliminate things. And just as, fifteen or eighteen years ago, I stretched out to get that – put it in and took it out – to get that look in that kid's eye and the way his mouth was open or wasn't – I mean a very particular kind of look – I'd do the same now. In other words, I can't find any freedom in abstract painting. I'm just as stuck with locations, a few areas of color in relation to some kind of totality that I want, as I was before. And so the problem of figuration is somehow irrelevant to me. I think some of the best painting done in New York today is figuration but it's not recognized as such.

DS: Could you give an example?

PG: Well, I think of my pictures as a kind of figuration. Obviously they don't look like people sitting in chairs or walking down streets, but I think that they are saturated with ... I think every good painter here in New York really paints a self-portrait. I think a painter has two choices: he paints the world or himself. And I think the best painting that's done here is when he paints himself, and by *himself* I mean himself in this environment, in this total situation.

DS: What about figuration in a more literal sense?

PG: I try.

DS: You do?

PG: Yes, and I think there's a psychological problem involved here. I've tried and I really want to, but I don't think it's possible. I can't. Perhaps another generation can.

DS: When you say you tried ...

PG: By that I mean the isolation of the single image, which is what figuration means. Is that what you're talking about?

DS: Yes.

PG: You mean like a Rembrandt?

DS: Yes.

PG: The self-portraits of Rembrandt?

13

DS: Or de Kooning's women.

PG: Yes, but when you look at . . . I was in Washington the other day and looked at that late self-portrait by Rembrandt. Honest to God, I didn't know what I kept looking at; finally, I didn't know what it was. I mean, next to it was a Van Dyck, and you said: 'Yes, there's a portrait; but, if the Van Dyck is a figure, well, what is the Rembrandt?' Actually something very peculiar goes on there. There's an El Greco head which is reputed to be a self-portrait. I don't know whether it is or not, but it's a terrific head: the beard and collar, the flesh and the bone, seem to be in some kind of constant movement. Whereas the Rembrandt seems to be so dense; you feel that if you peeled off a piece of forehead or eye, you know, as if you'd opened up this little trapdoor, there'd be a millennium of teeming stuff going on. I don't know what it is, finally. You know, Van Dyck gives some idea of a man, some idea of a portrait. You know, the more you think about these things, the less the things appear as they are supposed to appear. In those great Rembrandts there's an ambiguity of paint being image and image being paint, which is very mysterious.

DS: Do you ever get a simple desire to paint an apple?

PG: Oh sure. Certainly.

DS: And what happens?

PG: I do it too.

DS: With the apple in front of you or from memory of an apple?

PG: Memory of an apple. What's interesting is that a couple of years ago a group of younger painters started to paint figures and still lifes – and I think you had something like that going on in England. And a lot of reviewers talked about going back to nature and all kind of business, but, of course, it really meant going back to Cézanne and early Matisse and Corot. In other words, it's almost as if there were no innocence about their work at all. If they paint an apple from an apple, why not paint the Crucifixion?

DS: What happens if *you* try to paint an apple?

PG: Well, you've got Chardin, you've got Cézanne on your mind, and you've got everybody else on your mind.

DS: These get in the way? They come between you and the apple?

PG: I'm interrupting here, but I wouldn't paint an apple. What I really would like to do would be to paint a face.

DS: Do you ever start with a face?

PG: Oh yes.

DS: And what happens?

PG: Well, it's very hard to contain it. Now, these are dangerous waters. Because actually I hope sometime to get to the point where I'll have the courage to paint my face. But it is very confusing because sometimes I think that's really what I *am* doing, in a more total way. And at other times I doubt that. I am in constant doubt about this whole thing. We're talking about something which I wake up with and go to bed with every day, and I don't know exactly how to talk about it. What I really want to do, it seems, is to paint a single form in the middle of the canvas. I mean, one of the most powerful impulses is simply to make ... That's all a painter is, an image maker, is he not? And one would be a fool, some kind of fool, to want to paint a picture. The most powerful instinct is to paint a single form in its continuity, which is after all what a face is. This happens constantly on a picture. I remember last year I became so nervous about what I was doing that I finally reduced it down to the can on the palette with brushes in it. Well, that's real, that can with brushes. And I painted the can with brushes sticking in it, and I couldn't tolerate it. I couldn't face it. It was as if it

didn't contain enough of my thoughts or feelings about it.

DS: Was this because it became other people's clichés? Or something different?

PG: Something different. I don't know what the something different was.

DS: Was it that the form on the canvas wasn't the outcome of your experience of working on the canvas but only some kind of sign?

PG: Something like that. That's right. It became signs. Exactly. Now, I think you've hit it. It seemed to become signs and symbols, and I don't like signs.

DS: You wanted the actual experience of the thing?

PG: That's right. Yes. Therefore the whole thing got broken up, and finally I got involved in a more expansive, extended experience there, as far as I can figure out.

DS: Did anything come of the picture? Or did you destroy it?

PG: I destroyed it.

DS: But is it conceivable that a picture which might begin like this and might go through this process nevertheless was a picture you completed?

PG: Yes. But it wouldn't hold.

DS: All the same, might all this experience go into a picture that you preserved?

PG: And still have that single object, you mean? Yes, well, of course I see it that way. I see later that, as I look at my own pictures, they are to me – I don't know what they can be to anyone else – a kind of record of this journey. So that I see where I started with certain things – you might say objects – and then they became dissolved and then somehow the whole field becomes the reality. There's something very fascinating to me about the idea of painting a single object because it . . . I mean, why won't it hold? I've got about twenty thoughts mixing and merging in my head. Just give me a moment.

Well, I'll put it this way, I remember once, years ago in London at the waxworks – I've always been fascinated by waxworks, like everyone else . . . But, you know, there's something of waxworks in art; you know what I mean? It's a very valuable ingredient there. In Madame Tussaud's museum, with these life-size portraits of Gandhi and President Roosevelt and so on, you are in a state of ambivalence there. That is, if you regard it as art, they are too much like real life. If you regard them as real life, they're, after all, an effigy, an art. You don't know where you are. Of course, the frustration is that I would really like to go up and shake

hands with Gandhi and feel his warm hand and talk to him, but, you see, he won't talk, his heart doesn't beat. And yet I'm convinced that part of the fascination in visual art and visual representation is its impurity. I think that part of the strange fascination about a Raphael, for example, or a Piero, is the kind of frozen . . . It's not aesthetic, you know. I mean, we've all been mistrained: aesthetics, composition, and all that stuff. But if one really keeps looking at this effigy, which is, of course, highly formalized and schematized, it involves the erotic very much. It's almost real but it isn't. Of course, a lot of lousy art is built on this premise. I mean, a lot of lousy art is waxworks, of course.

DS: So there's the frustrating ambiguity of the waxworks and the frustrating ambiguity of the Rembrandt.

PG: Believe me, you've got me a little wrong. I maintain that the frustration is an important, almost crucial, ingredient. I think that the best painting involves frustration. The point about the late Rembrandt is not that it's satisfying but on the contrary that it is disturbing and frustrating. Because really what he's done is to eliminate any plane, anything between that image and you. The

Van Dyck hasn't. It says: 'I'm a painting.' The Rembrandt says: 'I am not a painting, I am a real man.' But he is not a real man either. What is it, then, that you're looking at?

PIERO DELLA FRANCESCA: THE IMPOSSIBILITY OF PAINTING

1965

A certain anxiety persists in the paintings of Piero della Francesca. What we see is the wonder of what it is that is being seen. Perhaps it is the anxiety of painting itself.

Where can everything be located, and in what condition can everything exist? In *The Baptism of Christ*, we are suspended between the order we see and an apprehension that everything may again move. And yet not. It is an extreme point of the 'impossibility' of painting. Or its possibility. Its frustration. Its continuity.

He is so remote from other masters – without their 'completeness' of personality. A different fervor, grave and delicate, moves in the daylight of his pictures. Without our familiar passions, he is like a visitor to earth, reflecting on distances, gravity, and positions of essential forms.

In *The Baptism*, as though opening his eyes for the first time, trees, bodies, sky, and water are

represented without manner. The painting is nowhere a fraction more than the balance of his thought. His eye. One cannot determine if the rhythms of his spaces substitute themselves as forms, or the forms as rhythms. In *The Flagellation*, his thought is diffuse. Everything is fully exposed. The play has been set in motion. The architectural box is opened by the large block of the discoursers to the right, as if a door were slid aside to reveal its contents: the flagellation of Christ, the only 'disturbance' in the painting, but placed in the rear, as if in memory. The picture is sliced almost in half, yet both parts act on each other, repel and attract, absorb and enlarge, one another. At times, there seems to be no structure at all. No direction. We can move spatially everywhere, as in life.

Possibly it is not a 'picture' we see, but the presence of a necessary and generous law.

Is the painting a vast precaution to avoid total immobility, a wisdom which can include the partial doubt of the final destiny of its forms? It may be this doubt which moves and locates everything.

FAITH, HOPE, AND IMPOSSIBILITY
1965/66

There are so many things in the world – in the cities – so much to see. Does art need to represent this variety and contribute to its proliferation? Can art be that free? The difficulties begin when you understand what it is that the soul will not permit the hand to make.

To paint is always to start at the beginning again, yet being unable to avoid the familiar arguments about what you see yourself painting. The canvas you are working on modifies the previous ones in an unending, baffling chain which never seems to finish. (What a sympathy is demanded of the viewer! He is asked to 'see' the future links.)

For me the most relevant question and perhaps the only one is, 'When are you finished?' When do you stop? Or rather, why stop at all? But you have to rest somewhere. Of course, you can stay on one surface all your life, like Balzac's Frenhofer. And all of your life's work can be seen as one

picture – but that is merely 'true'. There *are* places where you pause.

Thus it might be argued that when a painting is 'finished', it is a compromise. But the conditions under which the compromise is made are what matters. Decisions to settle anywhere are intolerable. But you begin to feel as you go on working that unless painting proves its right to exist by being critical and self-judging, it has no reason to exist at all – or is not even possible.

The canvas is a court where the artist is prosecutor, defendant, jury, and judge. Art without a trial disappears at a glance: it is too primitive or hopeful, or mere notions, or simply startling, or just another means to make life bearable.

You cannot settle out of court. You are faced with what seems like an impossibility – fixing an image which you can tolerate. What can be where? Erasures and destructions, criticisms and judgments of one's acts, even as they force change in oneself, are still preparations merely reflecting the mind's will and movement. There is a burden here, and it is the weight of the familiar. Yet this is the material of a working which from time to time needs to see itself, even though it is reluctant to appear.

To will a new form is unacceptable, because will builds distortion. Desire, too, is incomplete and arbitrary. These strategies, however intimate they might become, must especially be removed to clear the way for something else – a condition somewhat unclear, but which in retrospect becomes a very precise act. This 'thing' is recognized only as it comes into existence. It resists analysis – and probably this is as it should be. Possibly the moral is that art cannot and should not be made.

All these troubles revolve around the irritable mutual dependence of life and art – with their need and contempt for one another. Of necessity, to create is a temporary state and cannot be possessed, because you learn and relearn that it is the lie and mask of Art and, too, its mortification, which promise a continuity.

There are twenty crucial minutes in the evolution of each of my paintings. The closer I get to that time – those twenty minutes – the more intensely subjective I become – but the more objective, too. Your eye gets sharper; you become continuously more and more critical.

There is no measure I can hold on to except this scant half hour of making.

One of the great mysteries about the past is that

such masters as Mantegna were able to sustain this emotion for a year.

The problem, of course, is more complex than mere duration of 'inspiration'. There were pre-images in the fifteenth century, foreknowledge of what was going to be brought into existence. Maybe my pre-image is unknown to me, but today it is impossible to act as if pre-imaging is possible.

Many works of the past (and of the present) complete what they announce they are going to do, to our increasing boredom. Certain others plague me because I cannot follow their intentions. I can tell at a glance what Fabritius is doing, but I am spending my life trying to find out what Rembrandt was up to.

I have a studio in the country – in the woods – but my paintings look more real to me than what is outdoors. You walk outside; the rocks are inert; even the clouds are inert. It makes me feel a little better. But I do have a faith that it is possible to make a living thing, not a diagram of what I have been thinking: to posit with paint something living, something that changes each day.

Everyone destroys marvelous paintings. Five years ago you wiped out what you are about to start tomorrow.

Where do you put a form? It will move all

around, bellow out and shrink, and sometimes it winds up where it was in the first place. But at the end it feels different, and it had to make the voyage. I am a moralist and cannot accept what has not been paid for, or a form that has not been lived through.

Frustration is one of the great things in art: satisfaction is nothing.

Two artists always fascinate me – Piero della Francesca and Rembrandt. I am fixed on those two and their insoluble opposition. Piero is the ideal painter: he pursued abstraction, some kind of fantastic, metaphysical, perfect organism. In Rembrandt the plane of art is removed. It is not a painting, but a real person – a substitute, a golem. He is really the only painter in the world!

Certain artists do something and a new emotion is brought into the world; its real meaning lies outside of history and the chains of causality.

Human consciousness moves, but it is not a leap; it is one inch. One inch is a small jump, but that jump is everything. You go way out and then you have to come back – to see if you can move that inch.

I do not think of modern art as Modern Art. The problem started long ago, and the question is: Can there be any art at all?

Maybe this is the content of modern art.

ON MORTON FELDMAN*
1967

* This talk and others at the New York Studio School came about by invitation from Guston's old friend, the founder and director of the school, the painter Mercedes Matter. Guston conducted occasional seminars there from 1967 to 1974. He would drive down from Woodstock, replenish his supply of canvas and paint, have a big meal (usually Italian), and spend the rest of the day with the students, talking, showing slides, commenting on students' work, and ending up eating and drinking into the late hours with anyone still awake and able to continue the conversation.

I was on a panel once, sort of a popular panel, and someone asked the question about artists in society and so on, talking about support. I mean, real support, moral support. Would Van Gogh have painted if he'd been all alone, if he had nobody to support him? And I answered that he couldn't have. He had to have Theo, his brother. It occurred to me that it would be impossible. I mean, you'd have to be insane, like the man who says he's Napoleon. So I had Morty. I guess there are some other people, but I don't know about a lot of other people. But, in this sense, I need Feldman to tell me I'm not insane. He has a way of seeing which always more than fascinates me. I mean, it really involves me, how he sees. So that when I finish a painting, I call immediately. Or if I break down during a painting, I call him to come over. Not to hold my hand but to hear what he says.

I remember one time when I was beside myself –
I'd destroyed a painting I don't know how many
times. He lived at that time near me, a block away.
And I was practically in tears and I called him. He
said, 'I'll be right over.' And he came over and he
looked at the painting. He didn't say anything. It was
a painting I had destroyed a lot of. I'd been going on
it for weeks, and in desperation I'd done some
things, very spontaneous things, almost automatic,
like you do when you destroy a painting. And so I
told him all my troubles, and we went out and ate
and saw a movie on Forty-second Street. And then
he went home, and I went back to the studio and
painted all night and did it. I called him the next day,
at his factory where he was then working, and said:
'You better come over. I did it. I really did it this
time.' So he said, 'I'll be right over.' He looked at it
and he was quiet for a long time. He usually is. And
he said, 'You know, it's a marvelous painting, it's
terrific.' He says, 'Last night when I saw this
destroyed thing I had a feeling, as if I saw you on the
street from a distance and you were with a woman
that I never knew you to be with. But as I got closer
and closer it turned out to be your wife, Musa.'

Well, that kind of criticism, it may be elliptical,
but it's very important to me. Who wants someone

to tell you they like the red or they like the blue or something like that? Or it's better than the one you did before, or worse. And this winter Feldman was in Texas and I was in Florida, and again I'm going through some kind of changes and so on. I was doing a lot of drawings and I was really distressed. I was down to a line, a couple of lines. And he called from Texas and said, 'I'd like to come and visit you.' And I said, 'Oh, I'm going crazy, I'm down to one line.' He said, 'Hold that line. I'll be right there.' He was in Houston and he was on his way home, but he came to see me down there on the Gulf of Mexico. I picked him up at the airport, and all these drawings were on the walls and he didn't say anything. After dinner we went walking along the seashore in the Florida moonlight. And I said, 'What do you think of these new things?' And he said, 'You know, the last trick of Houdini was that he locked himself up in a trunk, they threw away the key and then threw the trunk off the Brooklyn Bridge, and he got out.' And then there was a long pause. We walked another five minutes and he said, 'But you haven't thrown away the key.'*

* See 'Conversation with Clark Coolidge' (pp. 149–51) for an alternative version of the Houdini story (sans punchline).

So you can tell what I feel about Feldman. He's a remarkable man. Cage is different. I don't know why I should bring that in, except that in the early fifties we were kind of a trio for a while. I met Feldman through Cage. I had known Cage some years earlier, in the late forties or so. John used to come to the studio and talk. Anyway, in the early fifties, John was enthusiastic about my painting. So, I think it's important, if not crucial, to have one person. If you can have one, you can have a million, it doesn't matter. But you need that one. One you can talk to. He gets on the stage in your theater, your drama. And one time I remember, it was very hard with Morty. About the mid-fifties or the later fifties, he didn't care so much for what I was doing. I was working with very heavy forms. And he implied that he didn't recognize me. He said, 'It's such a beautiful land you created, so how can you leave it?' He was still in that land and I was going away. I was working with very heavy solid forms and, well, I was doing what I had to do. But I remember feeling very distressed that he didn't seem to be as enthusiastic as previously.

Now Musa, my wife, who is very close to my work, is a kind of whipping post for me. I wake her up in the morning and say: 'Look at this, look at

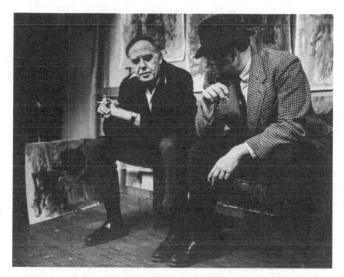
Guston in the studio with Morton Feldman, 1965.

that.' And she'll say, 'Well, it's beautiful.' And I say, 'What do you mean, it's beautiful? Why don't you say it's lousy?' But I have to see a look. She says nothing, but I have to see a look in her eye. And Mercedes Matter, also, was in my drama on the stage. Those three people. And she didn't care so much for the new development of things.

But it's a good source of energy to have these two or three people who are with you suddenly not reacting. And the reason it's a source of energy is because I remember feeling that you develop an 'I'll-show-them' attitude, which does give you a lot of energy. Because you can fall asleep with the other too. I remember thinking: 'These few people who are the closest to me and think they know me well, they don't know me at all.' And that became the most important thing, that the people closest to you don't really know you. Because if you're doing something that you're absolutely compelled to do, and they've been with you up to that point . . . I mean, my life hung on a thread over some precipice. Well, they don't know who I am. The hell with them.

I think that relates very much to teaching and everything else. You're all painters and I, or another teacher, or your friend, tell you something. You want confirmation in what you do, but what if you

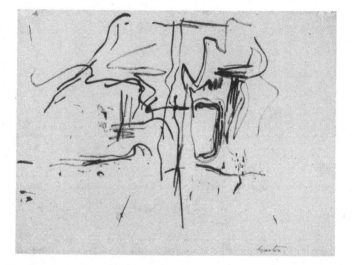

Untitled, 1950. Ink on paper, 16⅞ × 22 inches. Private collection.

don't get it? Well, that stage is a very important state. And then when they start liking what you do, you think there's something wrong with it! I'm going to react again. I think you need a protagonist. Absolutely. I'm sure this protagonist is a subjective creation, but that's the way it has to be.

ON PIERO DELLA FRANCESCA
1971

PHILIP GUSTON: I'm trying to think of what to say. There's so much to say, I don't know where to start. Driving in, I was thinking about what I would like to talk to you about, which is what I saw when I went to Italy last October. I came back just recently. It's about the third time I've been in Italy. You know, I'm not going to lecture. I'm just going to ramble, if I may. And if you want to interrupt or ask questions or make a statement, go right ahead. I've been to Italy, I think, about four times. And the reason I go there, if I can be autobiographical for a moment, is that when I first started painting, at about sixteen or seventeen, I fell in love with Italian Renaissance painting, especially the fifteenth-century paintings. By that I mean, especially two painters. And I can expand that to at least a half-dozen painters I fell in love with via books. I grew up in Los Angeles and you couldn't at that time see any painting there. I mean, there were a few Sienese primitives in the

45

L.A. [County] Museum. But I would haunt public libraries for reproductions, to see the paintings of Piero della Francesca, Uccello, and Masaccio. Those three painters fascinated me and influenced my work a great deal. I wasn't able to get to Italy until 1946, after the war, and stayed in Rome for about a year, and that was my base.

Now, I may be saying things you already know, but just bear with me. Arezzo is a hilltown about an hour away from Rome, and that's where the Church of San Francesco is, where the main body of work of Piero della Francesca is. It's the *Finding of the Cross* series. And so I would go there constantly and study. And as I re-go to Italy I see many other things, and what I liked five or ten years ago I'm not so enthusiastic about now. It's like there's an infidelity involved. You fall in love with somebody else and then don't see why you liked that other painter so much. But each time I go, the paintings of Piero don't seem to diminish. I mean, the effect on me doesn't seem to diminish. And I know I'm not unique in this. Lots of painters love Piero. He's one of those figures in painting that everybody seems to adore. And yet when I talk to many painters about Piero, everybody likes him for different reasons.

Before we show slides, I just want to say a few things about Piero della Francesca. I'm not an art historian and I'm not going to go into his life. It's not going to be a lecture on his work. I just want to point out certain elements in his work that have kept me under his spell, which, as I said, doesn't seem to diminish. On the contrary, it seems to expand and grow. And every five years, or every number of years, after a body of work that I do, I see his work differently. There's something very mysterious about him, very strange. One thing that's very interesting about him, and I didn't know this until rereading a book, I think it's the only decent book on Piero, by an Italian art historian named Longhi.* It's now translated into English, and I'd like you to read it if you're interested in Piero. I didn't know until recently that very little had been written about Piero. He was a kind of a forgotten master, who was greatly appreciated in his time. You've got to remember that he was a contemporary of painters like Uccello and Andrea del Castagno. And he was given full

* Roberto Longhi, *Piero della Francesca* (Florence: Sansoni, 1937), translated by Keith Christiansen (Riverdale-on-Hudson, NY: Stanley Moss Book / Sheep Meadow Press, 2002).

recognition, although it's debatable now among art historians, as it was also in the past, who influenced whom. I mean, Uccello did see the work of Piero. Piero did see the work of Uccello and Andrea del Castagno. However, that doesn't matter. They're both masters. All three of them are masters. And not until the early twenties were there serious studies made of his work.

It's very surprising because throughout the nineteenth century, with the growth of art history in England and Germany, much work had been done on Michelangelo, Tintoretto, Titian, but hardly anything on Piero. In fact, Bernard Berenson's several-volume book on the Italian Renaissance, devoting chapters and chapters to Raphael, Leonardo, Michelangelo, and Giotto, gives Piero hardly a paragraph.* He just says that Piero's someone obsessed with perspective and that he painted battle scenes. That's about all. I don't think he says much more. He gives him credit as an architect. And that's it. That was

* Bernard Berenson, *The Italian Painters of the Renaissance* (New York: Phaidon, 1953). This book, combining several earlier volumes, was originally published in 1930, although Guston dates it in the 1920s.

published in the twenties, just after the First World War. And, although I have no proof of this, I'm convinced that it was modern painting, by which I mean Cézanne and cubism and the work of Picasso and Braque and Léger, that caused a whole renewal of interest in the work of Piero. What I'm getting at is that this was my background in painting, my heritage. Although I've swerved and taken detours from time to time into getting involved with other Renaissance painters like Titian and Tiepolo, and later Venetian painters and then French painting. Well, that's endless. I always seem like a kind of pendulum or compass, trying to find true magnetic north. You know, that needle which moves around but finally settles on true north. Every time I start thinking about Piero, whatever else may have been on my mind seems to evaporate and I come totally under the spell again of this majesty of his creation.

Now, Arezzo is a very small town. I remember when I was first there, it was very battered up, in 1948. Because Arezzo was a hospital town for the Allies during the recapture of Italy, and so the whole place was a rocky bombed wreck. The Germans had it and then the Allies retook it. And the cathedral, when I first saw it, I thought

something had happened to it, because it was unfinished, the façade was unfinished. And the inside, unlike many other cathedrals in Italy, was like a kind of big barn. There was no plastering. The columns seemed unfinished. I've since learned that nothing happened to it, that the cathedral itself was unfinished. And then of course I fell in love with the cathedral because of the rough crudeness of it, the massiveness, the lack of any decoration. It's just a purely functional fifteenth-century cathedral, really a fabulous environment for this chapel, which is in back of the altar. And the subject matter of the frescoes has to do with the finding of the true cross and the victory of the Emperor Constantine. Although it starts on top with the Old Testament, the sacrificing of Abraham. The two lower panels are battle scenes. There are three tiers on each side. It's very free in its use of the iconography. On one side, facing the window, is an *Annunciation*, which is like no other annunciation ever painted. And then the other side is a *Dream of Constantine*, which is also a very peculiar thing, and the lowering of the Jew into the well.

But I'll never get over my first shock of seeing the frescoes. The excitement that I had when I

first saw it, after looking at many reproductions, was such that I had to go in and out, I was so nervous. Because what you first see, before you even recognize the subject matter, are these big soaring verticals and very full circles. And the color, which by now is somewhat faded but even so, is the color of faded tints, dull reds, milky blues, liver umber, dirty whites. Marvelous color. And all this in a geometry that I never quite saw before.

It makes Uccello, his battle scenes which I had studied so much, seem nervous and fussy, as marvelous as they are. But only in comparison, only when I'm in a certain mood to take sides, to make Uccello seem like problems that are solved. Fantastic problems, though. Problems of spatial projection to be resolved on the picture plane to make this very unique image. But the more I talk about Uccello, I'm always switching sides. Right now I could get excited about Uccello. But this time, last winter, I remember going to look at the Uccellos in Florence, right after I saw the Pieros, and feeling very disappointed. Piero seems to be some kind of, I have to use the word *cosmic*. As if all these forms, buildings and columns and draperies and figures, the way in which distances are located, the slowness of

spaces moving up and down, the spaces across and at the same time moving in and out like planets, are like a celestial system of some kind, which produces this feeling of wisdom. Or some kind of emotion which is filled with a wisdom that I didn't find in Uccello.

Uccello is of this earth. The armor is clanking, the lances are bristling, people are falling down and they're going into space. There's no interest in the subject matter with Uccello. With Uccello the battle scene is almost, and there's nothing wrong with that either, a kind of excuse. Not excuse, but a reason to get involved in these problems he was involved with. In fact, that *was* his real subject matter. And in spite of the fact that we have a *Death of Adam* in Piero, or an *Annunciation*, and we know what the subject matter is, the *Dream of Constantine*, the *Finding of the True Cross*, that also doesn't seem to be its subject matter. And yet, the more I look, I don't know what the subject matter of this is. That is, it's so indescribable to me. To be more specific, it's very difficult for me to talk about something that I love so much, except if I convey something of my passion for this. I suppose that's what I *can* do.

All my life I've had two reproductions hanging, as a friend of mine says, on the kitchen walls of my life. No matter where I've lived, they've always been in the kitchen, because I want to look at them when I have eggs and coffee in the morning or my drinks at night. And they're not of this series in Arezzo. They're individual panels. They're not of frescoes. *The Baptism*, which is in the National Gallery in London, which is one of his first pictures. In fact, I think it's very early in his career. The second reproduction I have hanging on my wall is of *The Flagellation*, which is a very late picture. In fact, one of his last pictures. Which doesn't mean that he died after that. He was also an architect and a mathematician, and his involvement with painting was diminished after this point and he got more involved in architecture. And also in writing his book, which was a treatment of perspective. Which he created, I think, although the ideas were current in that period, if I'm not mistaken. Ideas about whether you could make a logical system about the laws of perspective. Well, I shouldn't go into perspective here. What we think of perspective is not what they thought of perspective. I'll just leave it at that. I mean, principally and very simply put, perspective of that time

was involved to systematically give the illusion of, and have rules by which to work with, the projecting of forms into a deep space. But in such a way that all the forms are readably and rhythmically stated on the plane of the picture. And one of the great things, just to talk about this one point of the work of Piero and its inspiration for modern painting, revolves really around this whole thing of what we call the picture plane.

I know that that term is taught in most art schools and is always put down as first principles that you talk about. But I've discovered that what they mean by that usually is surface. Now that's the last thing in the world that I mean, that I think we're talking about. Because, in many minds, in thinking about painting, this rectangle on which we project an image or our expression of a non-image, a nonobject image, is a surface upon which you can make a fixation of some kind of configuration. Well, that is not what I mean by *the picture plane*, because the picture plane, as I'll point out to you later when we show some slides, doesn't exist factually. Per se. That is to say, it's not a physical thing. It's not a material surface. It's totally an imaginary place, plane, which has to be created by illusions.

Now what I mean by *illusions* is: if you put one color shape against another color shape, you're making an illusion. That's putting it very simply. Now, this imaginary plane ... I like the word *place* because it's an illusive imaginary place where forms of this world, trees, people, furniture, objects, momentarily come to rest. No, erase that. Not 'come to rest', pause. I think my great attraction to Piero is a sense of pausing. That is, as if all these forms, these figures, could have an existence beyond this momentary pausing. A lot of other painting, which doesn't deal with the plane with this kind of intensity or pressure, thinks of the square or rectangle as a kind of a hole which you just pour stuff in, and make it look real. A wax museum or something like that. There can be abstract wax museums just as there can be naturalistic wax museums. And that means that the forms have no future. They don't give promise of any continuity.

But in my case, I take detours sometimes. It's important to take detours because you come back to the main road with much greater intensity. My only interest in painting is really, as I go on and on, just only this interest, on this metaphysical plane where the condition exists of no finish, no

end, but infinite continuity. That is, the distributions of forms are in a condition which gives you the feeling that there was a structure unseen *previous* to what you see. Now, this pause gives promise to future structures never finished, always looking as if they're going to avoid this total immobility. That's why I say it's celestial. And that's not the condition of the great master Uccello, because there isn't that promise in Uccello, as great as he is. So I keep coming back to Piero.

About five years ago or so, these two reproductions on my wall in the kitchen got me so nervous that I decided I ought to put my thoughts in order. And I was painting very intensely. It was all during the winter, about a six-month period. I would come into the kitchen and see these things and then stay up all the night writing about it. It was a sort of self-commission. And I found that the more I wrote about it the more elusive the whole damn thing became. It was like painting. I wrote reams, just literally hundreds of pages,* and finally reduced it down to about a page. I realized that trying to write about this thing, or articulate

* These have not been found in Guston's papers.

it in a verbal medium, was as difficult as painting. I realized that what I was really doing was writing instead of painting. It was almost as if I wasn't even writing about Piero but writing about myself, I suppose. And I'd like to read you what I wrote. In any case, this is what came through that very fine funnel. It's called 'The Impossibility of Painting'. [Reads 'Piero della Francesca: The Impossibility of Painting'.]

When I was first, many years ago, under the spell of this painting, I was very influenced by it and naturally worked with many verticals and horizontals. But no matter how I paint, I seem to be superficially less influenced by it but actually more influenced by it, if you know what I mean. That is, I think probably I'll go to my grave puzzling about this generous law. I think, more than anything else, I want to acquire in myself, to evolve into, a space where I'll really know something about the generous law which must exist.

Let's see the *Baptism [slide is projected]*. That's not the true color. It's not in focus. That's the most delicious painting when you first see it in London. I don't know the exact dates, but I think he must have been in his early twenties when he painted it. And it has a fantastic freshness. I think

when a painter begins his work, there's a discovery that informs the work of his whole life. And that discovery always seems to me to be fresher and newer than his subsequent work. I've looked so much at this figure which is about to be baptized, taking off his shirt. The reflections on this pond, the gestures of the figures, the angels on the other side of the tree. The way in which the forms don't collide. They don't bump into each other, they move easily through each other. The feeling of that landscape moving, meeting the angels. The way that the tree is painted. A peach tree, I think. When I saw this picture first at the National Gallery with some other masterpieces (there's a Lippo Lippi, a marvelous annunciation of Botticelli, and a later Piero, a nativity), it seemed so simple compared to the others. In the other masters, everything seems to be full of flourish: Botticelli's leaves, for instance. But in the Piero each leaf looked like a sign painter would paint leaves, just painted in as if no account, no big deal how things were painted, no flourishes. It's a great lesson.

Let's go on to the other slide, Steven. These succeeding ten slides or so are from the *Cross* series in Arezzo, and they're in no particular order

because we couldn't get the slides that way. And in any case, that isn't my interest right now, to talk about either the iconography or the order from top to bottom. I just picked the details that looked exciting.

This is a small detail from one of the panels, which is actually a view of Arezzo. Even right now Arezzo looks very much like that when you come into the city from a certain road. But isn't that magnificent? Now, I ask you, what more did Picasso or Braque do than that, during those cubist years? I think they were trying to come back to that. I'm not belittling their work for that period. Not at all. I admire it very much. But here it is in all its purity, straightness, without expressionism, if you know what I mean? Well, there's no point in me going through part to part to analyze each form. That always bores me. I get too tired of a picture when I do that. But look at it for yourself. Not just here but later. Get some prints of it. Let it be your pinup and keep looking at it. It's absolutely a miracle of painting. The cluster of where the buildings are tightly packed in, and then the way the cluster releases itself and moves out so gradually.

If dates mean anything to you, and they're only meaningful in a certain sense, this series of

paintings was done over a period from about 1450 to 1460. I think he worked on it for about twelve years with some interruptions in between. And in fact, the theory goes that some of the panels were not painted by him but from his designs. I didn't believe that when I was first told it by an Italian historian. When I went there I'd gone with some accredited letters, so I was able to get some ladders put up for me. You see, the panels start from about the height of this room and then go on up about thirty-five or forty feet. And they're very hard to see, because the chapel in its breadth is very narrow. In other words, you're in a very confined space looking up. So I was able to get some tall ladders and planks and see the lower panels, which are the battle scenes that face each other, and the annunciation, at eye level. And it's true that it's pretty mechanically painted, so it might possibly be true. Well, they all say it is true. And the painting is different. But they're his cartoons and his designs. It really doesn't very much matter who painted them, because their grandeur and meaning are of course in the disposal of everything, all the forms through the picture. Well, that's what I could see at eye level.

AUDIENCE: Did you take the photographs?

PG: Oh, no. These are borrowed. You'd need a complete scaffolding to take photographs. I was lucky this last winter in Florence at the Masaccio frescoes, photographs were being taken. And for the first time I could get on the scaffold and see things at eye level. Touch and see it like you would a painting in a museum.

This is the Queen of Sheba. But I won't talk about the subject matter, because it's such a complicated work, this series. I blow hot and cold on certain panels, certain parts of this. The last time I remember being somewhat bored by the group of the queen and her attendants, but this time it hit me all over again. Well, first of all, this block is so marvelous, the way that moves right through without interruptions. These flowing rhythms. And then the way this arm moves out of this block. There's something about this figure with the hand, back of the queen here, kneeling. There's something about the distance, the spaces here, that struck me. You can't see it in the slides, but it's so marvelous here, the mixture of tensions of the space. The way the hand goes right out to that head and the way it's released again.

I know this is done quite often in representation of crowds in Renaissance painting, but it's

always delicious to me, the heads in front of each other, and seeing partial heads revealed through openings and so on. But nowhere, I think, is it as judicious and as immovable, as perfect, as here. I mean, in all the Filippino Lippis . . . I think only Masaccio, perhaps, comes up to this. I mean, this opening and so much head and eyes. This opening, that opening, this opening. Or I'll put it this way, in a very simple manner, because it's hard to explain, though it's always talked about, but the spaces between the forms seem as important, as charged, as the volumes themselves. It seems to me, this particular thing I'm talking about, this equilibrium which makes Piero 'modern', in fact appeared here for the first time in such a way.

Marvelous, the way he gets the hat, where the hat is. The saddle. That doesn't go down. The saddle isn't here, it's here. It has to be. I know that this can even be seen in the Sienese wedding scenes and festivals and all of that, but it's never like this. In other words, he did take and use what was current in his time. This desire to project into space, one form in front of another. But nobody did it like this! I mean, he took the very elements which were used on the wedding chests, but he did something with it.

Never in Piero does the rendition of a painting of a head and its features ever lose the volume of the head, the geometry of the head. The drapery, while being drapery, is somewhat like sculptured drapery. And there's a reason for that, because archaeology was just coming into existence at that time, and painters were very much influenced by sculptured Roman stone drapery, and Greek. Never does the drapery interrupt the mass of volume or area. The big lavender, or dull red really in this fresco, exists as a big mass in spite of all the folds here. And of course, the delicious play of hats and spaces leaves nothing to be desired. I feel completely fulfilled when I look at that. The horizontal edge is marvelous. That pancake hat coming down against the soaring other hats. The color, of course, is much deeper than that.

[A new slide is projected.]

AUD: What's the story?

PG: You know, I don't know. I forget what it is. It's always referred to as the *Lowering of the Jew into the Well* [also known as *The Torture of the Jew*], but I don't know why. Or I did know and forgot. Does anybody know?

AUD: They're trying to get him to tell where the cross is.

PG: Exactly. Now it comes back. I have a bad memory for iconography. The other thing that keeps me under the spell, so that I can look at these things forever, is the sense of ease of the forms. I mean, nothing seems labored. The disposition of the forms and the spaces seems natural, unforced, untortured. But I think one of the most thrilling parts that always stayed in my mind, maybe because I could get it at eye level and the up and down and across here was so striking, is the overlapping of the forms resolved in this particular suspension that I spoke of previously. It's so magnificent here.

You see, these pieces, as you might know, are blank areas that had deteriorated and so they were recemented, and that's why you don't see the completion of the forms. And incidentally, this also bears out the fact that not much attention was paid to this fresco for some centuries. It wasn't until the twenties or thirties and even more recently in the forties, now that Piero is recognized as such a boon to tourism, I suppose. I'm being cynical. Every week somebody's down there doing injections and putting the stethoscope to it and seeing

if it's going to lift. But had they taken care of it in the nineteenth century, as they did other frescoes, it wouldn't have been in this condition. But there's a reason that's always interested me; it has nothing to do with what we're talking about, but maybe it has. There's a fight that's been going on for some decades between Vatican City, which has its own art department, and the state, which has its own authorities in art. That is, they each have conflicting interests and that leads to all kinds of trouble about preservation of the fresco. Or removing it from the site, from the church, because of dampness and so on. So this fight keeps going on.

[A new slide is projected.]

You see, a slide such as the previous one, at that size it's so reduced you really can't see it. But this, though larger than life, is the way you would see it if you saw it and looked at it slowly to see the magnificent rhythmic disposition of everything. You understand, nobody posed for this. He made it. He created it. I mean, he put that horse there, that helmet, that spear there, that hand there, that tunic there.

Someday I'd like to talk to you about fresco painting, because the very medium of fresco had

a great deal to do with, or at least met, the artistic demands. There was a fusion between the technique, that is, the physical media of painting, and the concept. In fresco you work in sections, as much as you can paint in eight to ten hours, because you're painting on fresh plaster and it calcifies after eight or ten hours and refuses to take any more water. And when the oxidation of the lime, which forms a skin, happens, which is usually about eight or ten hours, you can't paint on it anymore. The lime skin is the binder. Therefore in early frescoes such as Giotto or some of the Sienese frescoes, they're painting huge sections in a day. But as the generations went on, up to Piero and Mantegna, where there was more and more interest in the realism of a form or the particularization of a form, the sections of the day's painting get smaller and smaller. So in Piero, if you would examine that, very likely the head itself might be a day's painting. That is, let's say from here to here. Maybe including that, I don't know. Maybe that would be one day's painting.

AUD: How big is that?

PG: That figure here, I'd say that's double the size. Perhaps a little more than double. About half that

size. And so you see, you finish your day's painting and then you, or your assistant, cut around the edge of the form, and then the next day he plasters right up to it. It's like a jigsaw puzzle. But obviously it has to go from top to bottom. You can't drip paint. You can't go up. I'm sure it was great fun.

In the Uccello battle piece *[The Battle of San Romano]* that's in the Louvre, everything is so closely packed, all these forms, that you really don't know which leg belongs to which horse. It doesn't matter, because it's just a sensation. And there's one panel of Uccello's where right at the edge of the picture, I think it's the left-hand side, you only see about two horses but there's about a dozen horses' hooves. And you just feel the joy, the pleasure, the painters had in doing that. I wish we had a detail of this. You should look it up in a book.

This warrior plunging the dagger into this man's neck, his head against his chest, and way back with the aid of some kind of half-moon circle, you get interested in that movement. I remember a group of painters who were working at the American Academy in Rome, and even though they had been there for a year and a half

they hadn't taken the *rapido* for an hour to go to Arezzo to see it. And they were painting as if they were still in Detroit. Minimal paintings. So I took them up there in the Academy station wagon. And I was talking about it, somewhat the way I'm talking now, and they were interested in it. I mean, they saw my interest. We were able to see it rather close because we got up on stools or chairs. So I was talking about that man stabbing the other man in the neck, and this one man said, 'Well, he looks so placid, you wouldn't look like that if you were stabbing somebody.' And I was just struck by the remoteness that so many of us have from art. We have such a direct way of thinking that it's like a movie way of thinking. That is, if a man is killing another man, he's supposed to grimace. But in fact, here, one of the great things about it is that he's killing this other man as if he's picking a piece of grass in the earth or lifting up a button. I mean, the greatness of it is, it always gives me the feeling that man will always do that. Like it's an eternal man eternally stabbing another man. A timeless stabbing. So he missed the point. He wanted him to look angry.

Look at that clump down there of horses' legs and hooves. Isn't that marvelous? And isn't that a

hat? Tilted like a disc, the movement of that against the towers. You could look at that hat and that vertical forever, but I think you need a hat and buildings to do it.

That's not Christ carrying the cross [pointing to slide]. That's the carrying of the wood. If you look down at the figure that's carrying the cross, there's one testicle showing outside of his panty there. At first, years ago I thought it was Christ, but certainly you wouldn't do that to Christ. So I think it's a carpenter or something that's carrying it.

That detail of the city is in the upper part of the picture [in The Discovery of the Three Crosses]. It's that small compared to the whole panel.

Let's go on. We could look at these a long time. I think my intention is to tell you what I'm interested in, and to arouse your excitement to look at these things on your own. There are a number of very good picture books. One is Kenneth Clark's book.* I don't like the writing, that's my prejudice, but the reproductions are excellent. So, you look at them for yourself and study them. Also

* Kenneth Clark, Piero della Francesca (London: Phaidon Press, 1951).

there are a number of small pocket books. You can find them across the street for just a couple of bucks. I have one with me to show you, which has a lot of reproductions in it.

AUD: *[inaudible]*

PG: Well, I think the attempt is to make what you might call a non-individualized face. An ideal face. When you see it, you don't feel this is Susie or Uncle Harry. You know what I mean.

That's not Arezzo but a close-by town. In fact, it's the town where he was born, Borgo San Sepolcro. This is a painting, in a chapel there, of the Resurrection. When you see this, the color is much more somber. Practically umber and ivory, a dull red. I remember this time I was struck by the bleakness, the landscape looks so barren and remote. This risen Christ against these sleeping soldiers, sleeping guards, produces a feeling in you that you cannot ever forget. I wish we had a detail of his face.

That's the *Annunciation*. On the left you're seeing the edge of the battle scene. In fact, the man stabbing the other man in the throat is in that corner, this side right here. That's a kind of chair form. But this annunciation is really like none I've ever seen. Piero has a way of displacing

a picture, quartered like that, each quarter almost being a separate picture. And yet the whole unity: the projection of God, and this window, Mary there and the angel, the way he's coming in here. He's so, I don't know, so slow. And so plain. No distortion anywhere. This he painted himself. You can tell in the painting when you see it. Those areas he painted himself seem to be more liquid somehow, less dry.

Well, we're switching here [as slide changes]. We're going back, now about 150 years. Giotto is what? About 1300, I think, although this was late. He painted this about 1306 or 1310. The other painter that I was struck with and thought about all year was Giotto. The main Giotto, really, is in Padua, the Scrovegni Chapel. He has a whole chapel. The chapel has a whole building for itself. We'll see a few slides from it. One wall is the *Last Judgment*. One side of the chapel is the Old Testament and the other side is the New Testament. But this is not from that. This is from a church in Florence, Della Croce, and it's the *Entombment of Saint Francis*. I have to explain to you that in the early twenties, in Assisi and in Della Croce, they repainted the Giotto frescoes. I suppose a rich Chicago Catholic or something came and said,

'We've got to do something about this.' And they were all repainted about twenty years ago, and they looked terrible. They looked like posters. Then, about 1950, they decided to take the repainting off so we only see what he painted. And that's the reason you see these splotches. But of course it's better to see what he painted, and have big blank sections, than to have some kind of a job done over the whole thing. Do we have a detail of this next? No, we don't. But I was going to say something. Can we go back to that other one? Am I running late?

AUD: A half hour left.

PG: Oh. I think I had something to say that I haven't formulated in my mind yet, about some feelings I had this time in looking at this Saint Francis painting of Giotto. In other chapels next to this are some of Giotto's contemporaries, and they're pretty good fresco paintings. You admire them, but when you come in here you're drawn in a fantastic way and you start thinking about what the differences are between the others and Giotto. I wish we had details of the brothers who are weeping, gesturing, kissing Saint Francis's hand, and so on. You feel, when you look at it, that Giotto wasn't painting a picture, that he wasn't

deciding a space. Which some of the other painters do: the figures are in there somehow to illustrate the story or to fit in a certain compositional scheme. But here it's a sort of a drama which is going on. I started to feel that I could identify with, or be drawn into, the drama which is taking place. I mean, they're not being watched. The brothers aren't being watched. They're not being looked at. It's a real scene, a real thing happening. And I came away feeling strongly, both from this and the following paintings in the Old Testament series, that Giotto had somehow in a magical inspired way entered into what he was painting. Into *what* he was painting. There wasn't the detachment that we see in Piero.

I'm showing you Giotto because it's another thing completely. And I don't believe in historical progress. That is to say, I wouldn't agree with the theory that art advances, that Giotto did this because he couldn't do the other, and then you have, of course, a series of advances, one thing leads to another. I don't think that's the way it works. I think that each artist is himself. In that sense, I would take an antihistorical position in relation to creation. But, go on.

Well, that's the *Last Judgment*. We should have many details here. That's all right. We can see well enough, no? Somehow, at this scale it may seem to you very schematic, and it is schematic. But somehow, when you see the original, it seems very grand. And of course, down below, especially the underworld, hell, the demons in hell, and in purgatory, are really magnificent. You must get a book with details of all the tortures that are going on with these figures. It seems that hell is always more exciting than heaven, for painters anyway. I looked a great deal of the time at the apocalyptic frescoes of Signorelli. Giotto's very Sienese. And the minor Sienese painters of the Apocalypse. Fra Angelico, for instance. Heaven is always very boring plastically, just a lot of verticals and forms. But hell, oh, they went to town with hell. Because there you could turn this around and upside down and chop people up and have lots of stuff to paint.

Look at that. I never noticed that branch. That's the *Annunciation* [by Giotto]. These are in the Scrovegni Chapel.

AUD: *[inaudible]*

PG: Yes, only two painters, Piero and Giotto. I couldn't show more. We'll do it from time to

time. That's a marvelous painting. You know, you have to realize that when these appeared, around the 1300s, this hadn't existed before. No one had seen anything like this. No one had seen such three-dimensionality of bodies, volume of figures, the weight of draperies, gestures. When you see Duccio, you see a bridge, you see vestiges of Byzantine, of icon painting, the drapery is done in lines. This is realism, but more than that. When you see this . . . I came out in a daze of weeping. Because you're so moved by belief. I mean, this belief. And nothing can be a substitute. Nothing can be a substitute for belief. And there's no point in analyzing it, in the sense that you could analyze and talk about Piero. And this is what puzzles me right now.

AUD: *[inaudible]*

PG: Looks like what? Oh, they all look the same? You want them to look different, each one different? Sure. It's humanity, you know? It's not individual persons. Again, you're so moved, as I was saying earlier about the frescoes of the recumbent Saint Francis, that you're just overwhelmed by Giotto's involvement in the drama. You can feel that in the painting of the heads, in the way the three figures are massed up there at

the upper right. You feel that as he was painting he was feeling it, each thing, each form, each strand of hair. He wasn't designing a picture. It would be fascinating, if we could, to make a comparison between this flagellation of Christ and the Piero flagellation of Christ. How totally different. Different ends of the spectrum. That hand. Just the hand is there.

AUD: What's this painting about?

PG: The sacrifice of the lamb, I think. I'm trying to recapture my feeling in contrast to Piero. You come out of the chapel and you're dazzled, I think, finally by the tenderness of Giotto. Just the human tenderness, because there's not one shred of flamboyance or form for its own sake. It's the other end of the spectrum from Piero. The disposition of the forms and spaces is not to produce any other sensation really, except to tell most clearly this narrative, this story.

TALK AT YALE SUMMER
SCHOOL OF MUSIC AND ART*
1972

* Guston was first invited to the Yale Summer School in 1961 and returned from 1970 to 1974. His daughter, Musa Mayer, describes one of these occasions in her memoir: 'Only once can I remember actually being present when my father was teaching; that was one summer, while I was still in high school, when my father went to lecture and critique student work at the Yale Summer Art School at Norfolk (Connecticut). I remember a beautiful estate with croquet lawn and big barn-like studios, and a mixture of feelings I could not untangle at the time. My father spoke informally, in a very relaxed yet intensely personal way. The students, initially shy, seemed to absorb his enthusiasm as the afternoon wore on, and the session ended with laughter and a barrage of questions. Clearly, they had found his talk stimulating. I had, too.' (Musa Mayer, *Night Studio: A Memoir of Philip Guston* (New York: Da Capo Press, 1997), 79.)

PHILIP GUSTON: These slides that I'm going to show you are kind of a mini-retrospective of work. I begin somewhere about 1941. About ten years ago I had a retrospective show in New York and some slides were made up, so I have a selection of those that continue to pretty much about a year and a half ago. I haven't had any slides made of what I'm working on right now. And some of you may think, 'Well, why all these changes?' Or note the fact that there are many changes. It's taken me years to come to the conclusion, or to the belief, that probably the only thing one can really learn, the only technique to learn, is the capacity to be able to change. And it's a very difficult thing. But as modern artists that's our fate, constant change. I don't mean novelty or anything like that. What I mean is that this serious play, which we call art, can't be static. I mean you have to keep learning how to play in new ways all the time. It's always

79

good for the first time. There's a popular Italian song, 'Per la Prima' – 'For the First Time'. It's about a love affair, but it's the same thing. It's all good for the first time, and then somehow that has to be recaptured constantly. So, shall we start showing slides? And we can continue to talk.

This *[Martial Memory]* is about 1941. I could say a few words about my interests and preoccupations in painting at the time. When I painted this I was very involved with certain fifteenth-century Italian painters like Uccello and Piero della Francesca, and at the same time studying the cubist paintings, the cubist period of Picasso and Braque and Léger. And I think I was trying to make some kind of integration between these two interests. I was very much preoccupied, as you can see, with overlapping of forms in illusionistic second-dimensional space. And at the same time, placing them so that a surface of two-dimensional rhythms would occur on what we call the picture plane. I was very involved with horizontals, verticals, diagonals, a very structured chunk of three-dimensional sculpture realized on the two-dimensional plane. From here I went on for two years in what I suppose you would call a very romantic period of painting.

I began getting interested in the Venetians a great deal.

This *[Sanctuary]* was painted while I was teaching in the Middle West: the city in the background, that kind of storefront, and so on. Painted during the war, about 1943, 1944, something like that. David Pease, you know your old friend Steve Greene posed for that?

DAVID PEASE: I know. He told me.

PG: You know that? I thought you'd be interested in that. I mean, I wasn't making a portrait. This *[If This Be Not I]* is about 1945. I'm just giving you sort of high points, or what to me are high points. This is sort of an opus, a large painting I worked on for about a year, in which I tried to summarize everything I knew about painting. You know, one of those opuses you can get hooked on and stay on for a long time. I have some details, so you can see how it was painted. The background is Iowa City actually, literally so. I was teaching there at the time. You see, previous to the first picture I showed you, I had been working as a mural painter on the WPA, the Federal Art Project in New York, and I'd worked with fresco and casein, all sorts of mural techniques. Cement paint, rubber paint. This was the first time I really had the

leisure time, when I went out to the Midwest to teach, to use oil paint. So it was a great joy, moving it around and working with atmospheres. I'd also become interested in a whole series, perhaps only about twelve paintings, dealing with children, the world of children. The world of make-believe and masquerade and so on. I never drew from reality. They're all imagined. I was glazing too at that point. First discovering the use of oil paint. For myself, that is.

That's about a year later. I started to become dissatisfied with what I had done and started to move on. I think a strong influence on me at that time was Picasso in the late twenties, those rich still lifes of his, where representational forms are compressed and made into new combinations, new shapes. And that excited me.

This was a series I called the *Porch*, where I had these groups of attenuated figures. I lost the interest in them as children. This was in 1946 or 1947, after the films of the concentration camps started coming back, and photos and stories. I think I consciously thought of these children not as children but as lost, agonized beings. Using the porch idea as a kind of confine, as if these figures were all compressed. The figures and legs of chairs and

columns and horns and so on all became like flat pieces of paper just pressed against each other. I did this in 1947 or 1948, and then I probably reached the end of this subject and this preoccupation. Then followed a year of destroying everything. Everything seemed unsuccessful to me, and I couldn't continue figuration. How to explain that? The forms I wanted to make couldn't take the shapes of things and figures. In other words, a sort of a split occurred, a very unhappy thing that happened. And, after about a year of destroying paintings, this picture [probably *Tormentors*] happened, which I felt okay with. Although there were still remnants of figuration in there, but I felt that I had to drop figuration. I mean, it just had to go. It was a very lengthy struggle to do that. I felt torn, you might say, between conflicting loyalties, which some people go through. The loyalty to my own past, and the other loyalty of what you might still do. Or what you might still become, which is of course unknown. That seems to be the pattern of my life as a painter. I don't seem to know any other way.

I went to Europe after that last picture. I stopped painting for about a year and just drew in Europe. That's [*Drawing No. 2, Ischia*] a typical

sketch of the island of Ischia, a portion of it, which pleased me. Those little dots are windows of this town. Down below is a stone wall which you can't see very well from a distance.

I started then in Italy and finished in New York. It didn't feel real to me to make a figure from bottom to the top. I felt like making dissolved things, fragmented.

Then I went on. This is about 1949 or 1950 [probably *Red Painting*]. I'd come back to New York and got to know most of the painters that are now called the New York School, or what was later called the abstract expressionists, although nobody used that term at that time. Then things started happening in my painting that I felt more comfortable with. I might explain it this way: working with paint, having the least preconceptions of what I was going to do when I started putting on the paint. I mean, treating the act of painting very much as a process of interaction between you and the paint and the surface in front of you. A give-and-take, I mean to say, between feeling an urge for gray, an urge for red, just a blind urge, and putting it on. And then not knowing whether it's right, or not even caring about whether it's right, and doing something else. And

then it spoke to you, and then you reacted. That kind of thing. In which case, you might say I gave up the idea of the masterpiece, you know? And began to see that taking out (many parts are simply erasures) was putting in.

That's a drawing from about that time, a big ink drawing [perhaps *Drawing No. 4*, 1950]. Again, the feeling that you're making marks, and leaving yourself open enough or nimble enough so that things happen as you work. That is, I found it very exciting in contrast to my previous way, my former pictures of the forties, where they're very consciously structured and planned. So this was a great refreshing, stimulating way for me to work. And also, another great lesson was the lesson of extreme attention while you're doing it. I mean, split-second timing. Like the whole field becomes an electrified field where every mark is magnetized. I did a lot of drawing, hundreds and hundreds of drawings, as we all do. I look back on this work and realize that the last five years I've just reverted back to structuring and making many drawings. And now I find *that* refreshing. Process is very important, but I have a great nostalgia for this way of working. I may have to return to this discovering business.

I was once on a panel with a group of artists: Ad Reinhardt, Motherwell, and so on. And Tworkov was on it, and we were all talking about how we worked, and Jack said he liked to leave the studio when he felt he had something to work on the next day. And I was shocked by that. I thought it was horrible. I was very critical of that attitude. I thought it was like promising yourself a goody. I mean, then you clean up and go out with friends for dinner and you feel good because you know you've got something to work up the next day. I was shocked because at this time either you did it at once or not. The thing you did then at that moment, that was it. So that the painting or the drawing was in fact an evidence, you might say, or a document or a record really, if you want to look at it that way, of the creative moment. And that's what I was really excited about.

It was also a discovery that there was no such thing as accident. There was no such thing as being erratic, really. There was no such thing as a mistake. Sometimes I'd start drawing and, you know, the mind is quicker than the hand, and I don't like that. I want the hand to be, if not ahead of the mind, at least simultaneous. And so the impulse is to go to the right with the full pen of

ink? I would go to the left. And then something would happen, like a sensation of a mistake, so I would follow the mistake. But then, when you're through, there's an image that you've always wanted to see but you didn't know it. These things weren't planned, you understand.

That's the way I would do a still life at that time. A can, open. A pear. I don't know what else. But the discovery that lines are energies, lines and spaces are energy. Chiefly, and it is still true now, my own demand is that I want to be surprised, baffled. To come in the studio the next morning and say, 'Did I do that? Is it me? Isn't that strange!' I enjoy that. It's some kind of need I have.

I don't know what to say about these [for example, *To B.W.T.*, 1952], except just to show them to you. I'm showing you the drawings and paintings that were done concurrently about 1952. Very heavily painted, very much overpainted and erased, covered up, repainted, so that a lot of the brush marks are simply erasures. I wasn't even thinking about what the picture was looking like, just getting certain things out of the way. I mean, the reds that you see in the middle would be over there, or up at the upper left, and they were wiped

out with some dirty white. That's why it looks like that.

These [for example, *Fall*, 1953] were mostly done with bamboo. Slit bamboo sticks and India ink.

So I began becoming interested in drawing in terms of masses rather than linear. I seem to alternate between linear drawing and getting color in a drawing by having masses of strokes. And that reflected the painting at that time. Masses of color. Vibration of masses of color.

We're going over the years here very quickly. About 1955–56. As I got interested in masses of color rather than spots, you might say, there was a growing interest in forms. I remember having a strong desire to come back to more solid forms. These pictures are about seven feet high.

Strange how one views one's own work. It changes over the years. There have been times, like four or five years ago, when my work changed very decidedly into a figuration, and I couldn't look at this. I was reacting against my own work. I thought it was terrible. Too general, too diffuse. Not committed enough. And now, I haven't really seen them until today, they're sort of pleasurable. I mean, I feel detached from them,

but they're pretty nice. It's possible ... That's another very plaguing problem or question: how one sees one's own work.

That's about the time I wanted to become more solid, heavier with paint. More positively placed, positioned. These were the drawings I was doing at that time. And the drawings became more figurative.

That's one of those little throwaways that you find later in the sketchbook and you say, 'Look at that! Interesting' [referring to *For M (Drawing No. 29)*, 1960]. So you keep it. I remember starting with just some drops of ink. You see where that ball is? And below there's a sort of heavy accumulation of lines. So that first happened, then it grew into that membraned ball. And then I thought, 'Gee, it feels like a balloon. I'll release it from some forms down below.'

I was very definitely involved with imagery, even though the imagery was unrecognizable to me, bordering on fantasy. I suppose you'd call it fantasy, fantastic form. I can only tell you that it's very difficult to talk about one's own work. But naturally I can only talk about what I remember consciously. What they look like is not for me to say. I mean, I can't control that. But I remember

being very strongly aware of forms acting on each other. Putting pressure on each other, shrinking each other, blowing each other up, or pushing each other. I mean, affecting each other, as if the forms were active participants in some kind of plastic drama that was going on. I think I was aware of and strove for that. In other words, if a form or a shape or a color, pattern, seemed inert to me, wasn't acting on another form, out it would go. I felt uncomfortable with it. It wasn't paying its way. It wasn't doing its job in the total organism. And they're doing all sorts of things. They're walking, they're holding each other up, they're supporting each other. All sorts of situations. And I felt them to be true to my feelings at that time, in that they reflected, in a metaphorical way, human emotions.

Sometimes they became various combinations of different animals together. When I got to the red head of that thing, it felt like a trunk and I wanted to pull it out, pull it longer and longer. I didn't plan the eye, but the eye somehow got in there. These are gouaches, rather small in size [such as *Actor*, 1958].

I had been very involved with the paint too in this period, about 1958 or so. By that I mean not

just forms acting on each other, but the black seemed to be swallowing the red, and another form of the red swallowing the black. Almost as if the very colors, the very paint, the very matter, were doing things to each other.

Then there came at this time, the early sixties, a real desire to paint heads. Figuration. So many of these forms come from still-life forms. I mean, I would start with a couple of objects on the painting table. Cans even. And then that's how they ended up.

From here on, there's a whole period of work missing, from about 1962 to 1968, which I don't have slides of, in which these head and still-life forms were dealt with. Very stark, not any colors. They're mostly black, gray, and white. And so I have to jump into about 1968, after about a year of vacillation. I remember coming up to Skidmore, the previous summer when I had done this, and I remember telling how I was doing drawings with a ruler. And I was, practically. I wasn't painting. About a year and a half of just drawing, and this tug-of-war. I mean, I became very reduced. Some of the drawings are just one or two lines. And they've never been shown. I wish I had slides of them. And then reacting against that, with a

very deep desire to paint tangible things. And it began with just the forms around me. I mean, my shoe on the floor. That's just the underpart of the shoe. Books. I did lots of shoes and lots of books. What's the matter? It's a book. I must have done about a hundred paintings of books. And lots of shoes. I focused on shoes and books. Lightbulbs. Just common things around. I wanted to wipe the whole slate clean. Get rid of art. In your office, Bob, there's a slogan that says: 'Forget about art, we're busy . . .'?

BOB GREENE: A Grandma Moses quote.

PG: Grandma Moses, pretty good.

BG: 'Art means nothing. It's keeping busy that counts.'

PG: Keeping busy. I have a quote to match that, almost as good. By another primitive, John Kane. Remember John Kane, the Pittsburgh painter? He said, 'There's only one problem with painting and that's the ants.' Because when you paint, you'd be up on the hill painting the Monongahela River and the open-hearth plants, factories, the steel mills, and the only problem was the ants.

So at this time, I really felt like: The hell with art – pay attention. I mean, I would say, 'Just pay attention.' And somehow I went through the

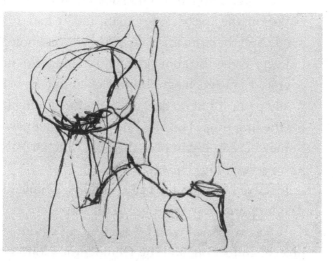

Philip Guston, *For M*, 1960. Ink on paper, 18 × 24 inches. Collection A. J. Pyrch, Victoria, British Columbia. Photograph: Rudolph Burckhardt.

mirror here. And then followed about two and a half or three years of just ecstasy. Just pure joy. After this period of struggle, this awful period of tug-of-war.

Oh, yeah, that hand. I called it *Paw*. Then I started having romantic fantasies about when, in evolution, the ape became a man, and he had this hand. And then the first line he drew, you know? I'm very romantic about the whole thing. So, of course, I started having fantasies about how I would paint if I never saw any painting. Doing it for the first time. The first line drawn. That paw. Somewhere in Egypt near the Nile. The Ur Valley or something. The first line.

It started over on the right, and in a couple of days it moved over, way over to the left.

What happened was, I was painting common objects and so on, and the Democratic Convention took place, in 1968, and like everybody else I was very disturbed about it. It seemed to connect with way back in the thirties when I was just beginning to paint. In Los Angeles I had done some pictures of the Ku Klux Klan. The Klan was very powerful in L.A. in those years. They were used to break the unions which were starting to form. And I was leftist in my thinking, I mean

politically, in those years. So I did a series of pictures of KKK and somehow it all came back in a circle. I did this painting, a bunch of KKK in a room [possibly *Discussion*, 1969]. It's sort of in a nice pink Sunday comic color ground, peach pink. And when my nephew saw it he said, 'It looks like the school where they're learning how to be KKKs.' So this is like the school.

Then I was off. You couldn't catch me for two years. I was off. And that's what I did. Then they started becoming very real to me. Stories of what they did. I couldn't keep up with the ideas. Like a novelist, I had to write down memos to myself: Paint them! They're eating. They're having beer and hamburgers. They're out in the car. I mean, ideas kept coming so fast I really should have hired some assistants and tripled the production.

That's a kind of abstract, a little too much Uccello. Then, of course, who wants to paint a head? What's nicer than having a hood to paint, and stitches? Also the desire to make dots. These are in progression in time, up to the show.

AUDIENCE: How big is that?

PG: About five feet. It's one of the smaller ones.

AUD: How long did you work on that? Do you remember?

PG: On each one?

AUD: On this particular one.

PG: It was done in an hour and a half, two hours. Or thirty years. Either way you want to look at it. I remember when I did this [*Book and Hand*, 1969], very compulsively. It's a big canvas, about an eight-foot canvas. I wiped out another canvas with white, and real juicy pink oil paint always looks good on a tacky white ground. But that's what happened one night, that pink fat hand. And it went very quickly. An hour. Like a big billboard. That became the size of the book, the little book. That's what that is, a little book, a red book. And I wanted to see how long I would get a kick out of the scale. And it lasted, so I put it in the show. And I still get a kick out of the little book.

That's the city [*City*, 1969]. Well, as I told Arthur last night, I felt as if I'd opened up Pandora's box here. Everything came flowing out. Because that's what we ask for, isn't it, really? To have this thing happen. That's why most of the time I say, 'Gee, the last thing to be interested in is painting.' Per se, you know. I think other things release you to make paintings.

Now they're outside the city. That's a big ten-foot picture [*City Limits*, 1969]. It felt so good to

make that car, and then put them inside. In fact, as a kid, I went to Mexico in a Model T just like that.

Yeah, you could put a wristwatch on one guy, smoking, he's got a little blood on him. There's marvelous things you can do. I think a story is the most marvelous thing in painting. I mean, to have something to paint, to have a story you particularly want to tell.

I call them very laconic titles, like *Driving Around, Looking Around, Edge of Town*. Very out-of-pocket titles, nothing fancy. Out of the pocket.

That steering wheel becomes like a hot dog on a big poster or something [as in *Edge of Town*, 1969, or *Caught*, 1970]. But that's what happened.

That's a big one. Like a ten-foot picture. Ten and a half feet.

The title of this is *Remorse*, like sad. They became very real to me. And it was a great pleasure. I didn't go into New York. Or I went to New York but I wouldn't go see a show. There were a lot of retrospective shows when I was in, but I hadn't the slightest interest. I would have to send elaborate telegrams to de Kooning about why I couldn't come to his big show at the Modern. I just didn't want to look at any painting. I was really living in this world, and I just didn't want to

look at anything else. I remember Barney Newman called me, he was having this big show at Knoedler, and I said, 'Barney, I really . . .' I lied. I said something was wrong with me and I couldn't come. I just simply couldn't. I didn't know what I would do or say, if while I was doing this stuff I had to go in a room with these big striped pictures. And I like his work, but I just couldn't.

That's a nice picture. They're talking. All sorts of possibilities. They're philosophers. They can have ideas.

That's a good small little panel, a quickie.

Well, then, of course, a back view of an unnamable, anonymous man. And he appeared through a number of canvases, just a back view of him. I like this one, the way his head is rolling on his shoulders. *Sheriff*, I call that. Somebody said that looks like Ad Reinhardt from the back. And I guess it does a little bit.

That's one of the earlier ones, I think [possibly *By the Window*, 1969]. I got a big kick out of the stylized helmet and the realistic hand, of course. Smoking. With a cigar.

And then, of course, once I had the characters, then I knew what kind of rooms they are in. What kind of furniture, lamps, chairs.

That's a big long one. I always got a kick, imagining how big the figure would be. His hands, his arm, that is. That's called *Dawn*, and I painted it all night and then it was dawn. I live in the country. And the birds started. And those are the telephone poles outside the studio. That was the last touch when I put the birds in. It felt good to put something in that was right outside happening.

That's a big one. A big pleasure. The size of the seat, shoes, compared to characters in the car. Like Gulliver, you know?

A guy throwing bricks. That's it. When I started painting bricks, I thought, well, a brick fight. I never saw a brick fight. It's marvelous to paint something you never saw. And all the pleasure of the bricks going every which way.

Another big pile-up. That's another opus. As I was saying, in many of these pictures, like this one, I would work two or three days on drawings. A whole bunch of drawings, not finished drawings but germinating drawings. And then start painting directly. Just pin up all the drawings. I hadn't done that for years, and it felt very good to do that.

That's called *A Day's Work*.

You get very confused. When I started having them smoke cigars, I wouldn't remember how

you hold a cigar. I don't smoke cigars, I smoke cigarettes, of course. In many pictures, people would say: that's not correct. But, as I was doing it, I couldn't remember which way the cigar goes. I mean, you want the cigar, you're painting, you're thinking of shapes and spaces. So I thought, 'Oh, the hell with it! He can hold it any which way. What does it matter?' Just so it gives you the sensation. And of course somebody said, 'How do they smoke?' Well, that did occur to me, but I gave that up. How do you smoke through a hood?

That's one of my favorite paintings, called *Bad Habits*. Where that green bottle is in the middle, that was a real happy thing. Some pictures weren't all planned. There were lots of surprises, too. For instance, right in the middle of the two figures was a sheriff. I was going to do another sheriff picture. Well, it didn't look right. I'd seen it before. I did it before. So I swished him out with white, scraped him out, and swished white on. And then somehow I thought it needed a little green, and then I started laughing. I thought, I'll make it a huge whiskey bottle, a big bottle between them. So things like that happened.

That was a very ambitious structured picture, which I did a lot of drawings for, positioning. It's

called *Cellar.* A lot of figures just going down cellar, diving into a cellar through a trapdoor, and bricks flying in the air.

And then naturally a big deluge picture, a big end-of-the-world picture.

There's a whole series I don't have slides of, I didn't send down. They're still up in the studio. A series where I had parodies of art. I mean, I had them going to an opening. I had some looking at a Rothko. Just parodies about art. They became artists. Having discussions, with a palette. Guys pointing to the window talking about nature. Then, in between, the other guys pointing to a palette where all the colors are, just a full spectrum of paint on a palette. And then, of course, they're painting. Naturally, he'd be painting hoods. I mean, if horses painted, they'd paint horses, no? That's a good painting [*The Studio*, 1969]. Very tightly organized.

That's the artist's model, yeah. All that. Of course, as I went into this I was very grateful that I knew how to draw, that I had years of drawing. Because it's based on drawing, actually.

I wanted to call this *Oy* [possibly *Daydreams*, 1970]! Remember, those of you who love the early cartoons, Mutt and Jeff? That's my greatest love,

the early Bud Fisher, not the guys who imitated him. Who is the small one? Mutt. Jeff is the tall guy. Mutt was the short bald-headed one. Well, I think they were both bald-headed. But Mutt in consternation would grab his head. Two fingers always appeared beside his bald head. That's great, the early Bud Fisher is really great art.

Well, that's the one [*Red Picture*, 1969], looking at the Rothko, yeah. He's looking at field painting. I just loved him. Like: What the hell is that!? That's painting. And it's amazing how this formula, the slits for eyes, became so expressive. I've done a few others since then. Well, a number. I'm kind of leaving this subject and moving on to other things. But there are a few I've done since the show. And the range of expressions you can get with those two slits is incredible. They can look tender, they can look angry, surprised. It's stylized like in a Noh play, the stylization has a range.

Well that was a big canvas [*Flatlands*, 1970], about the last big one I did before the show, where I didn't do any drawings. I just really started from one end. I started on the left end, like in the pictures from 1950, I don't think I even stepped back to look at it. I just worked my way from left to

right. And I even got to the sun. I think what I wanted was what a friend of mine said: 'It looks like you put all forms, all the props, in a paper bag and then spilled it out.' I wanted that feeling.

Well, I think that's about the end of it. I'd be happy to talk with you, if you want to talk. Or make statements, anything.

AUD: *[inaudible]*

PG: Well, Chuck Close and I were talking. He was telling me his story about his change. That's how it started. You were telling me about Europe and you were beside yourself, forgetting about art and finally getting to the point where you were doing what you wanted to do, or getting close to what you wanted to do. So I told a story about, I guess, about 1967. I'd had a fairly full career as a painter, but I couldn't accept this new stuff. That was the problem. Months would go on, and I couldn't accept it. In the house are hanging some few things I kept, some of these pure abstract things – they looked very good. And then in the studio I would do these things, the guys in cars and all that. While I was in the studio, they were done with convictions. That's what I meant. I did them, then I'd come in the house to eat and whatnot, and I'd look at these beautiful things from the

past and I'd think, 'The hell with that stuff in the studio, that's terrible! I can't really stomach it.' I'd get sick, I'd stay up all night. Then I'd run back in the studio, and then the things in the house looked terrible. These three beautiful lines which are so satisfying. So, you can fill in between the lines.

There was one point in the middle of this stuff, I wanted to roll them all up and hide it, not show it. I mean, you have no idea. They were so worn with pushpin marks. Up would go the pure things. Big sigh of relief. 'Whew, I can live there.' Come in the next day – 'I can't stand that, it's got to be dirt.' Down they'd come. Up would come the drawing with cars, this stuff, books, shoes, everything, ahh! The only way I could get over that torture, as I was telling Close, was one night, solo drinking, I thought, 'There's got to be a solution to this.' So, I thought, 'Okay, I'm dead. I died.' And that idea stuck to me. It started like a playful game, but it became sort of serious. What if I had died? I'm in the history books. What would I paint if I came back? You know, you have to die for a rebirth. And so that released me. And not just released me, it gave me a beautiful extravagant sense of irresponsibility. That's what

I wanted. Because I'm full of the culture of art. But I had to throw over my own past. That was it. And of course, my very old and dear friend, Morty Feldman, I'd been telling him about this stuff when I'd come into New York, but he didn't want to come up to see it. Then finally he came up, and he was, I think, pretty upset. So, you lose friends.

But I think Baudelaire said, 'Second to the pleasure of surprising yourself is the aristocratic pleasure of surprising your friends.' And I think I wanted my close friend Feldman to say, 'You mean that's you?' He was close to my work for twenty years. And I wanted to feel as if I was saying to him, 'You think you know me? You don't know me.' It's curious.

We could talk for hours about this whole resistance. I mean, we all have one or two people. Van Gogh had Theo. It doesn't matter. It can be one or a million. But you need one or two. That's who you paint for. And when they come in the studio, there's a certain look in the eye. And if they say it's beautiful, then you say, 'What do you mean it's beautiful? Why don't you say it's lousy?' But if they don't say it's beautiful and there's a certain look in their eye, that look is what you want. So,

you don't just paint for yourself. You'd be insane if you just painted for yourself. I mean, that's insanity. So Van Gogh was not insane, really, because there was Theo. I mean, he might have been sick or something. He was an artist. So, there's always that problem of one or two dear people who are close to you. In love, aesthetically, in friendship, it's all the same, it's all connected. They get so close that you have to say, 'Get off. You don't know me. There's parts you don't know.' And so I'm just waiting for the day that Morty comes up and says it's fantastic. He will.

We're talking about something very important really. Because it has to do with change in yourself and everything. And the willingness to move, to make a move. I'm very careful. But then, we're all constituted differently. Some people are more audacious than others. I think Pollock was audacious. I'm not that way. Pollock was like a spider that Musa and I were watching the other night. It was coming down to the dinner table from the lamp and we couldn't figure it out. He's going this way? No, he's going that way. A spider throws out a secretion, no? And he follows. I mean, Pollock had the temperament to throw this thing out like a lasso and . . . Well, *courage* is a bad word, really. I mean,

none of us are really courageous. It's necessity. Sometimes it's the only thing you can do. So, he would throw this thing out and follow wherever it went. I'm more of a Kafkaian, Kierkegaardian. I'm more careful. Everybody has different kinds of temperaments.

AUD: This is probably minor. I was curious that all of a sudden I started seeing you sign the paintings P. G. with a circle around it.

PG: Very strange, yeah. But the strangest thing is that most of that is a very practical thing. There are certain paintings I keep, won't sell. And the ones I won't sell I sign P. G. But this winter I was working on a still life, or just some pieces of wood really, not a still life. A ball and some grainy wood, just lined up like that on the table. And there was a whole area below on the canvas that I really didn't know what to do with. I didn't want to just fill it up. Well, the picture hung around a week and I kept looking at it. And one morning, automatically I just, almost unthinkingly, made a big yellow ochre nameplate, studded, and an enormous P. G. And I didn't want to necessarily keep the painting. Then I followed with a number of paintings which do that. I don't know what it means myself. The only way I can think of it is,

like in some of those paintings I've done since this where I put my mailbox number, 660, on it. You know, you write letters to people and on the back you put your address. 660 stays in the mind and so it creeps into a painting. That happens. But this idea of signing a painting seems funny to me. The whole idea of signing a painting is funny, so I think, 'Well, I'll make it enormous.' Then I thought, and I haven't done it yet, 'What if I made a whole painting with just P. G.?' You know, the way you see a detail. In a Goya, say? A big painting. Well, it's a passing fancy.

I went to Europe right after this work. The show opened and we went to Italy for about seven months. I'm an Italianate. That is to say, I love Italy. I'm not Italian, but I love Italy. I've been there many times, just loving it. And I wanted really to see early frescoes of Last Judgments and end-of-the-world paintings. Particularly Romanesque paintings and Sienese fresco painters who paint huge marvelous frescoes of the damned, all the tortures in hell, and so on. Heaven is always very dull, just a lot of people lined up. Like trumpets, they're all lined up. There's not much to look at. But when they're going to hell the painter really goes to

town. All kinds of marvelous stuff. That's when they really enjoyed painting. So I feel we live in comparable times. Oh yeah, and I want to paint that. I don't want to copy, but I feel that's the big subject matter. I don't know how it's going to come out. Well, I've begun. I've begun with this story.

CONVERSATION WITH
CLARK COOLIDGE*
1972

* 'An after-dinner conversation in the Guston living room on Maverick Road in Woodstock. The routine of my visits was usually that I would come down in mid- to late afternoon and we would have drinks and a leisurely supper collaborated on by Philip and Musa. Philip seemed to like to delay going out to the studio as long as possible ('as you'll see later in the studio', etc.). But then, when it had become unavoidable, at 10 or 11 p.m., he would open the studio door and we would go in among the often thirty to forty new pictures. There, in my memory, the talk would become much more wild and interesting. But, of course, by that time the tape recorder was long forgotten.'
– Clark Coolidge

CLARK COOLIDGE: Well, you were thinking about what I said about the image.

PHILIP GUSTON: When you looked at that picture [*Paw*, 1968], you were saying that it's incredible what it takes to make an image, no?

CC: How close you could come to having it not be an image and yet still be one.

PG: Oh, I see. Well, when I'm painting it, if the image locks itself in there too quickly, or if I'm aware of it too much before I do it, then it's boring and I wipe it out. I mean, who the hell wants that? You'd rather have the image in your mind than just have to look at it, isn't that so? I'd rather think about something than actually see it.

CC: How much do you think, how much do you see, before you put that down? That's the gap that's interesting.

PG: Well, it's very vague. It's not nebulous, and *vague* isn't the right word, but it's like hovering, you know? It's not solid in your mind.

CC: I mean, did you think of a hand?

PG: No.

CC: How did you start? I mean, since that's there.

PG: Well, I'd been doing some hands previous to that, those pointing fingers and all that stuff, and then I was through with that. I didn't want to do it again. I think there was some repainting on that paw. Whatever was there previously, I erased it.

CC: Was it a hand before?

PG: Some kind of a hand, but it wasn't a hand with a stick, drawing. That I didn't think of. In other words, I just started with some white on that pink ground, and roughly, vaguely, I know what it isn't going to be. It's not going to be an elephant or a tree.

CC: You saw a hand somehow.

PG: A hand, yeah, but I didn't know how it was going to appear or anything like that. But it came, as my images always come, very rapidly, and that rapidity has to do with the image and what it is as you're doing it. Which has to do with when you stop, because you stop the moment you recognize it. I don't mean recognize it as a noun, or as

an image either, but recognize the minimum of what you need of what's there to make this thing exist. I'm always excited by the thin line which divides the image from the nonimage. What's exciting about an image is that at any given moment it would take so little to wipe it out completely, to have chaos, to have nothing there.

CC: What about the time it takes to physically put that paint on?

PG: Quick. It's very quick.

CC: There isn't any drag at all between ...

PG: No, because if it feels right, if the pistons or cylinders are going right, you can't predict that or control it. When you're in that condition, many things happen. First of all, you don't see yourself painting. One way to test that you're not there is when you constantly see yourself doing it, and that's a drag. I mean, you might as well be wrapping up Christmas packages or something. I mean, you just see yourself doing something, like hammering a nail in a door, screwing something to something else.

CC: Sure. You're not in the activity. You're out, watching the activity.

PG: That's right. You're watching the activity while you're doing it. So that's when you know

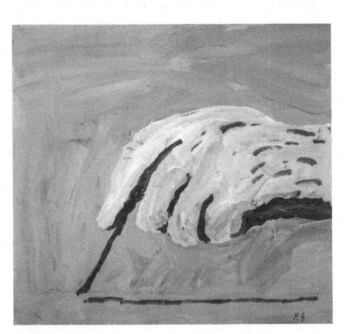

Philip Guston, *Paw*, 1968. Acrylic on panel, 30 × 32 inches. Private collection.

you're not there. But at that very exciting moment when it all comes together, you're not even aware that you're painting it. You don't even see the brush. I don't know how in the hell it happens, but the brush just seems to go by itself like it has its own life. And of course it's what I meant by the third hand. There's a third hand at work here.

CC: Well, I was thinking about the enigma, starting with your middle-sixties pictures where you're painting it up out of the paint and there's a lot of erasures, and that's the point where you said something like 'The recognizable image is intolerable because it's too abstract.' And I was thinking maybe there's an equal if not greater enigma in wanting to see the thing that you even have imagined in some way as an image actually in paint. I mean, that might be something that wouldn't necessarily be thought of as enigmatic. But the process of going between a mental image and painted image . . .

PG: Can become enigmatic? Yes, I've done that, too, what I've described as process I didn't mean to imply was the only and exclusive way I work. I've also, to test myself almost . . . You know, boredom can set in pretty rapidly, boredom of one's

processes. Something you do can become a way, can produce predictable results. It doesn't work and you get bored with that. And I became, in some of those pictures of 1969, 1970, fascinated with whether it was possible for me just to do the opposite of what I had been doing. That is to say, to work in an opposite way.

CC: You thought of it that way.

PG: Exactly. As you know, you've seen in the studio many sketches and so on, that I would do before I started painting. Well, I'll take away mystery and enigma. That comes later. You don't start with that. What you start with is a kind of itch, a desire, a strong desire to see what you imagine, or preimagine.

CC: I remember you said that once.

PG: Just to see it! Like you might think: wouldn't that be fantastic to see a hand eight feet long!

CC: Because it can't be the way it is in your head.

PG: Exactly. Because the moment it gets into physical matter, when it gets onto the picture plane, in this flat mysterious thing we call the plane . . .

CC: It's all different.

PG: It's *all* different. It gets warped and it's billowed and shrunken and pulled and . . .

CC: It's a different physics.

PG: Exactly. I've thought a lot about this and it may border on a kind of voyeurism in a way, because it's almost a desire to see what the hell this would look like. I'm going to make a very extreme silly example, as if we were in a room with a party of people we all know, all friends, a social evening, and suddenly you start imagining, what if they all started screwing each other? What would it look like? And I would imagine these scenes, not screwing scenes, but these characters and figurations I was working with. In a room, in a door, there's a window, there's a light. And if I put that all together in a natural spontaneous way, in my way of working, I wonder what the hell it would appear to be like, you know?

CC: People in positions you never see them in.

PG: Exactly! And even though the work has become, what's a stupid word, 'figurative', and so on, 'non-figurative', that's not the point. Because I was never trying to duplicate visual data or anything, I was making a total construction of some kind. So there is that kind of itch and desire just to see it. And then the enigma becomes what I think you in the past have called a 'clear enigma.' I've always liked that combination of words, because the enigma is sometimes thought to be something

fuzzy and mysterious and misty. But then the enigma consists, in my case, of having pulled aside a curtain, almost like taking away the fourth wall of a room and looking at its contents.

CC: Right. Like opening up the side of a building in New York and seeing in each one of those little cubes.

PG: That's right. I once had a conversation with Harold Rosenberg where we were talking about the enigma, and unfortunately I feel he got my intention all wrong. Because he brought up the subject of Magritte and I said no. I insisted on saying no, because I think there's a world of difference between fantasy and enigma.

CC: So do I.

PG: Because I think to have a table's legs turned into claws or paws, or a shoe ending up into toes, is fantasy.

CC: And that, to me, means it's understandable.

PG: That's understandable. And I don't mean I'm against it, because I like Magritte. I just wanted to locate it. I mean, Magritte's fine up to a certain point with me, but I don't think I could enjoy that forever.

CC: Well, enigma, to me, often has to do with common objects. I think of fantasy as something

almost embroidered by the mind. You start out with something and you make something fantastic out of it. Which probably has to do with your sexual or whatever drives. I mean, you elaborate on it. And that's what Magritte looks like to me, like ideas fantasized.

PG: That's right.

CC: Taken one step further.

PG: Like, it could exist. Which is *good* fantasy, in writing and certainly in painting. I believe Magritte is not really traditionally a surrealist. I think he's a fantast, basically.

CC: I think he's close to writing, by the way. I think he's very verbal.

PG: Yeah. I think one reason why he paints in as tasteless or styleless a manner as possible is to eliminate anything that would be in the way . . .

CC: Like sensuality.

PG: That's right, sure. Or any paint technique. In other words, he's painting in a dry commercial manner, like a sign painter of the old days, so that this object that he makes should look as clearly as possible, and in the light of day, as if this is what it would look like if it existed.

CC: Yeah.

PG: Well, that's fantasy.

CC: Just simplified a little bit by the process of painting.

PG: Well, that's in the technique, in the nature of the medium.

CC: Almost cartooned, in a way.

PG: That's right, sure. Well, what the hell is enigma?

CC: Enigma is totally baffling, for one thing.

PG: Chirico, in that marvelous self-portrait at the very outset of his career, painted himself in profile, in a box, and around the box, lettered in around the frame, he says in Latin, 'What shall I paint if not the enigma?'* Then, sometime later, in reaction against the cubists, and he painted these things at the time of the cubist revolution, he said that he didn't want to reconstruct the world, which is what the cubists were doing. He said he wanted to paint the world in such an aspect, and in such a light, as if it had never been seen before. Now is that the enigma? It's not a fantasy.

CC: No. Reconstruction of the world is fantasy.

PG: In other words, you might say that the cubists were fantasts. A kind of genre fantasy. I mean, it

* Chirico's Latin translates as 'What shall I love if not the enigma,' but this is how Guston phrased it.

122

was a fantasy about café life, bottles of wine, and *Le Journal*, a kind of genre still-life painting really.

CC: Because, to me, enigma always comes with the feeling that it came from out there, somewhere I haven't ever seen, or ever been. A fantasy I identify as being internalized. Like a reconstruction of things you've seen and taken in.

PG: Yeah, but even if it comes from out there . . .

CC: Well, I don't know if it does. It probably doesn't. But it has that feeling of otherness, although it might just be this [object on table].

PG: Yeah, I know what you're talking about. But, even though it has a feeling of otherness, it seems to me there must be this kind of pull, like an umbilical cord, to an image, to an object. And it could be, as you say, a banal or everyday object, but it has to have, somewhere along the line, a feeling of a certain kind of recognition.

CC: Yeah.

PG: As if you've never seen it before.

CC: Now you're putting your finger on it. It's very difficult to talk about.

PG: The recognition must be as if you've never seen it before, and yet you *have* seen it before, perhaps something forgotten.

CC: Maybe that's why it has that charge. It's not something consciously known, but it is something you have seen. Or maybe it's two things you've seen that are then put together.

PG: In collision, uh-huh.

CC: I mean, I have this feeling about collisions and juxtaposing. But I don't like the word *juxtaposition* because it sounds like art history.

PG: Yeah.

CC: I mean *this*, or *this*, or wherever it happens to be. And I don't mean me manipulating it. See, 'cause why I said 'outside' is because the feeling of enigma to me is always that it came to me, beyond my doing it. I believe what you say about the umbilical cord must be true, but nevertheless the image has that feeling of unknownness.

PG: I know.

CC: Not your own familiar fantasies recombined, but something that just absolutely stops you. As if we looked out the window and saw something that we'd never seen.

PG: Yeah. To be specific, to go back to that painting of the paw, and we were talking about the state I was in when I did it. I remember very distinctly that it happened quickly, maybe five or ten minutes of painting. The right accent in the right

place, and then the dots on the paw. Because the proportions it took began to push it away from the human and it became an animal's hand, or partial . . .

CC: Beast's . . .

PG: A beast's hand. And against that salmon-colored plane, indefinable, you don't know what the hell it is, there's no horizon line or anything. And when it was done I looked at it and my heart started beating and I started to get very excited, and I said, 'Gee, that's like the first hand that ever drew.' In ancient Egypt or in the Valley of Ur or something like that. And then I started thinking about man and about the missing link, since we really don't know what happened. I mean, what did the man's hand look like, who first drew a line or wrote something or made a mark on a rock? Now, was it like a paw? Didn't it look like a beast's hand? It must have. Maybe it was half-beast, half-human? I'm going way off here, but . . .

CC: You know what that makes me think of, though? The enigma is the first time something happened, too.

PG: Yeah, tell me about that.

CC: Well, I just happened to think, if you're thinking of the first time a man ever made a mark on

anything, then somebody seeing that, or the man himself doing it, and realizing it had never been done . . .

PG: Oh, I see.

CC: He's having the experience of enigma, maybe. Because that had never happened before.

PG: Oh, I see what you mean. Of course.

CC: Which leads back into art, and why we do this.

PG: Sure.

CC: Every time we do something we're trying to make the enigma. We're almost trying to 'produce' enigmas, which may be an impossibility. But the first time of anything may be . . .

PG: *Of* anything. I know.

CC: That could almost be a definition if you wanted.

PG: Well, that gets us into the whole area we were talking about in the kitchen, when we were bitching about other artists and being very bitter about the scene, both in poetry and in painting, being very disenchanted with certain artists. And I was talking about de Kooning's show, and you were talking about certain writers and what they were doing. And it just occurs to me now that you're saying that the trouble with the work is that they've stopped doing things for the first time. So therefore it has no enigma to it, no

mystery, and all they're left with then are their own mannerisms.

CC: Right.

PG: So then it means that to be an artist you always have to do something the first time.

CC: Yeah. It also means you always have to be discontented, probably.

PG: That's right.

CC: Which is the rub.

PG: Yeah.

CC: But you know what? I think the reason I get so pissed off when I'm talking about other failings, the limitations of other poets, let's say, is not so much them. It's that they keep bringing up to me my own limitations. They keep reminding me of the times when I didn't do it, when I held back or when I repeated. You know what I mean?

PG: Oh, I see what you mean. Of course.

CC: And I don't want to be reminded of that. When I look at art I want to be pushed in the direction of, let's say, the enigmas. I don't want to be reminded of what I did.

PG: That's right. They make you see what you hate.

CC: Yeah. In yourself.

PG: Hate about your own work.

CC: Exactly.

PG: So that's where the discontent comes in.

CC: Yeah. I think really that's the discontent. It goes beyond people and friends or whatever. I mean, that's just the basic discontent.

PG: So then, if one were to make a principle of it, you could make a principle of discontent. Discontent is a very difficult thing to learn.

CC: The other thing I was thinking about: Some of these newer paintings, contrasted against the mid-sixties dark paintings, are mainly an image in space with no history. There's nothing around them. The sixties ones, they're surrounded by their history, right?

PG: They're surrounded by their past. I mean, where they've moved from.

CC: Their states.

PG: Their states, that's right.

CC: And I just wonder how the process changes, from working up through states which are then left there . . .

PG: Into these images, you mean? Like that book [*Untitled (Book)*, 1968]?

CC: Yeah. It seems, like you said, like a reverse of what you were doing before, a reverse of a process.

PG: Well, if you concentrate on a single object, or something somebody has made marks on so it looks like a book . . . I had no idea it would become so bent. I think I wanted to make it feel like pillows, or not like pillows but like a kind of ancient stone carving. In fact, some of the books, as you remember . . .

CC: Are absolute slabs.

PG: . . . are like stone. They become like tablets.

CC: Yeah.

PG: Well, what can I do? I didn't feel like putting it on a table. I didn't want to make a wall in back of it. I didn't want it to be on a specific plane, or located in a space. There is no space, because the whole space is . . .

CC: The space is within that book.

PG: . . . is within the book.

CC: I mean, all those little lines, that's the history, right?

PG: Yeah. That's right. It's there, it's in the image itself.

CC: In the past, which is what a book is.

PG: Sure, exactly.

CC: But then it's will, actually.

PG: Will?

CC: Well, the decision to start with an image . . .

PG: To focus on the object, yeah.

CC: . . . and put an image on, rather than starting with paint, as in the mid-sixties, and see how it comes up. It seems like the process really did change.

PG: Did change totally. Absolutely.

CC: It's really interesting how that could happen.

PG: Well, one of the things that plagued me in that transition . . . I mean, don't think that during the sixties, in those black and gray pictures, or even the fifties, there weren't repeated attempts to make specific objects. There were. But I couldn't retain it. They would have to go. And then a picture would finally come about because of the removal of the images.

CC: You think it was a struggle to do this [new pictures]?

PG: Yes, I think so. As I remember, at that time I resisted because of a fear I had of specificity. And if I were to speak critically of myself from this vantage point now, I feel I made an aesthetic of, or was too open towards, the idea of ambiguity. Thinking then that if I didn't allow myself to be specific with images, by working then with exclusions, there resulted a certain kind of ambiguous

thing where it almost was something but wasn't something. The brush seemed to make the form and so on. Well, a lot has been written about that, about the powers, or the effect of one area on another area, acting on each other and so on. I think what happened was that I became weary of that kind of ambiguity.

CC: Because that wasn't what you were trying to do.

PG: Exactly!

CC: That's really ironic, you know . . .

PG: We never even talked about that before.

CC: That whole aesthetic came up out of erasures.

PG: That's right.

CC: A whole 'beauty' of . . .

PG: Yeah, I know.

CC: Some sort of horrible . . . mistake.

PG: Misunderstanding. I just had my fill of it and I reacted against it in the most violent way. And that's the reason I turned and then started these very pure drawings. I couldn't even paint for that year or year and a half. Just like clearing the decks and saying, 'Well, let's see what one line and another line do to each other.' Just that, you know? And that's a very important period because, even though it's objectless, in a real sense it's very close to, and led directly into,

painting a book, a shoe, a hand. The everyday common objects I started painting. And it wasn't just a desire for tangibilia, though that too was there – almost counter to the whole idea of the flatness of painting, which I detested. Because I think there's a hunger for touchability. It's touch. To feel a form.

CC: Sure, because paint is tangible.

PG: That's right. So that I felt that maybe there's an ambiguity that I haven't even dreamt of. In other words, what would happen if I did paint a simple object like a book or a hand or a shoe? That finally became to me the most enigmatic of all. It seemed to me like an even greater enigma. Or, rather, a deeper ambiguity. It's a different kind of ambiguity I wanted. I was weary of that whole thing that had gotten so accepted, which made it repulsive to me and thrown back to my face again and all that. An ambiguity that became so diffused and generalized that there was nothing left of it any more.

CC: That's really clear. I can see your sense, in the sixties, that those paintings were like dragging your own sludge with you.

PG: Yeah.

CC: And then to have that sludge held up as a great abstract work . . .

PG: That's right.

CC: That must have been really a tough thing to . . .

PG: Terrible. I know it.

CC: Because you want the clarity. You want the discrete, in the best sense.

PG: The discrete?

CC: *Discrete* is a word I like in the sense of, not social discretion, but discrete objects. Bounded edges. The edges aren't ambiguous. That's another thing, that you could have ambiguity of edgelessness or you could have an ambiguity of absolutely edged . . . I don't mean objects, but bounded . . .

PG: You mean monolithic?

CC: Well, some of the last paintings that you did really got into that area. After you spewed everything out of your mouth and there was stuff in the air.

PG: Just floating around.

CC: And it was all tangents. And absolutely discrete images, and the fact that they were so clear made the gaps between them and their relation to each other even more enigmatic or ambiguous. You wanted that clarity, I think, to get back to being able to deal with them at all. Because otherwise I think maybe you had your own smokescreen going. Is that a possibility? I mean, those gray

pictures might've begun to seem like you had too much of your past still hanging around. I mean, *you'd* have to say that, but . . .

PG: Oh, yes. But that has to do with what we were talking about previously.

CC: And that's a whole fascinating process in itself.

PG: Oh, sure. Well, as you know, in the sixties the final form that appeared, a black shape, a head, a form of some kind against a lot of overworked dense surround, I became fascinated with that form having lived in other places before it came to rest in this one place. This absorbed me very deeply for many years. But now, in these recent pictures you referred to, with these fragments floating around, none of those were overpainted or repainted. It's almost like open-eyed dreaming, you know? As if I were in front of the canvas, dreaming and *almost* knowing what I was going to paint.

CC: How about where those things are?

PG: I didn't worry about it. I didn't worry about where, and more often than not it worked, that I just trusted my instinct for location. So maybe I had to do all that, ten years of that sixties painting, to feel like, well, I don't want to repaint anything anymore. I mean, let me just put it there,

put that shoe there, put that bottle there, put that guy's mouth there, and that stick of wood there, and that brick there. Yeah. And in fact, I don't even think it's trust. I think that's an artificial way, a kind of conservative or academic way, of talking about it. Actually, I discovered over a period of time that there are two elementary or basic ways my forms work anyway. Either they're coming together or they're going apart. And I think that's about all that composition is anyway.

CC: Never still.

PG: That's right. They seem to want to clump together and stay there, and that's okay for a moment. But then they want to move apart, and then want to go back to the center again, like a control center, as if that's home. And home lets them out, magnetically, for a little while, just to enjoy themselves.

CC: A rest period.

PG: Rest. And then they want to come back again. So there isn't too much accident involved anyway. I think that's a myth.

CC: I think so, too.

PG: I find I'm so intimately involved with these two movements that I don't think I'm risking anything. The only thing I really have to do is get

myself to paint while I'm dreaming. That's about all it amounts to. Does that mean anything?

CC: Yeah. It makes me think about how the positions of objects, or arrangements of things, have always fascinated me. Like these objects on the table. You might call these accidental arrangements, but, I mean, not the artistic, this-balance-that kind of thing.

PG: No, we're not talking about that.

CC: Maybe there's a way of getting objects to exist more like they exist, not the aesthetic ways you have in your mind. Maybe that was what was meant by 'accident' in a sense?

PG: Well, accident has no real meaning any more. It had a momentary meaning in the early years of the century, when Duchamp, or Man Ray, or maybe it was Max Ernst, one of the early dadaists, dropped a string on some setting plaster, and of course the string made an interesting and fascinating surface. But I doubt whether that was even an accident, because there are physical forces involved.

CC: Well, I'm just sort of hammering against the aesthetic history of manners of arranging elements in a painting, which are so well known that you know them in your sleep. And you don't want to do that, because it's done and done and done.

PG: Well, there's no desire to. I mean, there's no surprise.

CC: And yet you want to see things in relation and nonrelation, but you don't want to see them that way. That's why I'd rather see this [table objects] than a painting that's all balanced.

PG: Well, look, anybody would rather look at life than art. I mean, I would much rather drive my car to Saugerties [near Woodstock, New York] and just look at all the buildings and rocks. But the fact is that when you put down some paint on a surface, let's say it's a red shape of your pack of cigarettes, and then you mix up some gray and put down the table that it's on, it's not what you see in real life anyway. It becomes itself. We all know that. But the question is: What *does* it become there in this field that you're creating on? There's meaning in everything. The question is: What kind of meaning? Let's see. At this point, what were we talking about? Control, as against no control?

CC: I guess I was talking about habit, actually. Learned methods of relations. The kind of thing that is so nonenigmatic that it's just past history. And yet there is a fascination with the way things are arranged, in a painting or here, regardless. As

long as it isn't the same damned old way of relating.

PG: Things that you've seen again and again, yeah.

CC: And I was trying to get through that to your method of painting now. The fact that you no longer follow where a thing has been and . . .

PG: I'm not so involved with process. You mean, actual physical process?

CC: Yeah. I mean, where this shape has been in these various places and now it's here. And you say: 'It's done when it's been everywhere I can think of.'

PG: Yes, and comes to rest momentarily.

CC: But just momentarily.

PG: Just momentarily. That is to say, that it must then feel as if it could go somewhere else. It's just pausing. Which is, of course, the promise of continuity. It means not death. It means promise of continuation of life. But actually I'm more fascinated now with something different than that. I almost want to call it the Egyptian feeling. That is to say, I don't want something to look as if it can move and be somewhere else. I want it to feel almost, not entirely, as if it's just there forever that way.

CC: So therefore, what you said before has changed? About your forms always going together or

coming apart? Now that you're talking about this Egyptian sense of the thing always being there.

PG: There. Well, I know that sounds different, doesn't it? It sounds conflicting. Well, I guess the answer to that is that I'm fascinated with both, really, at different times. In the work I did last winter, I was very involved with the feeling of forms moving apart and coming together. Forms feeling as if they had left home and then were coming back to this control center, eventually. And of course, to be psychological for a moment, what is this center? The center is me. That's what the center is, right?

CC: Right.

PG: But then in this summer's work, in some of those panels you were talking about, I became fascinated in another way with not that, but with forms just being there. Almost static, not movable. Why, I don't know.

CC: Well, I think that's probably because that's a quality of the act of painting, to get something down. Everything that's in the sense of that phrase. To make it stay there. To stop it, in a sense. Like that book, to make it *be* there. Maybe that's part of the original impulse for making a mark at

all. To have a part of yourself, an act of yourself, be on the world.

PG: That's right. Well, *there's* something I think I'll probably constantly keep vacillating or wavering between, movement and no movement. I think it's true of my whole past, as far as I know my past, to be fascinated by the one and the multitudinous. Sometimes I'll put a lot of forms into a picture and think: Why do I need all that? I really don't need this multitudinous feeling of forms. The world is filled with multitudinous forms. I really am looking for one form, a static form, from which the multitudinous forms come anyway. Like that bulging book we're looking at now. It's a sculptured book and yet it's done very simply, in a very minimal way. It's one of the best books of the series. There's just something about having a single form which is there in a space. There's no movement to speak of, visually. It's just there, and yet it's shaking, like throbbing, or burning or moving, but there's no sign of its moving. Now that book, I may be reading my things into it that other people don't see, but I don't think so.

CC: No, I see what you mean. It's vibrating.

PG: It vibrates! In other words, it's like nailing down a butterfly but the damn thing is still moving around. And this seems to be the whole act of art anyway, to nail it down for a minute but not kill it. That's what I mean. Whereas in the act of painting sometimes, when I don't feel so all together, and I want to keep in motion, I'll paint movement. I mean, I'll just put down a lot of things. And finally that doesn't satisfy me, and I always wonder why it doesn't satisfy me. But it doesn't sum it up for me. There's no need for it. That is to say, instead of painting all those forms moving around in the pictures – what the hell, I could just as well pull up the shade and look out the window on the street. Why do I have to do it? I don't have to do it on canvas, but I want to do what nature doesn't do. I mean, I can look out and see trees blowing, wind moving, and things are happening. I don't have to duplicate that. But what I don't see is a single form that's vibrating away, constantly, forever and ever and ever to keep vibrating. And that seems to be magical as hell, enigmatic as hell, really. Gee, I never said that before, that way. Now that book is really moving.

CC: That goes back to my feeling that we've talked about before, that in art you always work between opposites. Between stopping and going, stasis and movement, abstraction and figuration.

PG: Yes, that's right.

CC: I think it's like a machine that keeps us going, like electricity.

PG: It's a tension between the two.

CC: Between gaps, between poles. Which causes a lot of our dissatisfaction, because we go more to one side.

PG: You mean, a necessary dissatisfaction.

CC: Yeah. Because at any one time it's more one or the other.

PG: Veering.

CC: When we're toward this, we think maybe that one's wrong.

PG: That's right.

CC: But we don't realize that we're constantly moving. You never really stop anything, unless you die. Wherever that is.

PG: But even that I think should be accepted. Well, it's been a bad couple of months, as you know, but nevertheless I did a couple of very small oils. That's all I've done in these two months. Each one is a head of a guy with a cigarette in his mouth.

He's just smoking. An off-profile or something like that. Now those heads look like they're dead. I mean, they don't look like the thing we're just now talking about at all. I did them both in one day, or two days, and because of other things I haven't been able to work, but I do go in the studio to do this and that, and I see them, and those two heads have kept me going. And what I think about in my thoughts around that, and I know I'm going to burst out in these new pictures very soon now that my pictures are back and the racks are built and all that stuff, is . . . Now don't jump, because I'm contradicting everything I just said.

CC: Well, we always do.

PG: We always do. I'm thinking about death. That is to say, I don't mean about me physically dying, I don't mean that, but about forms that absolutely don't move at all, that are just dead forms.

CC: Well, dead forms and live forms, that's another two poles.

PG: The only life in these forms is the smoke. These two heads are like dead stone, dead mummy heads, glazed and dead. The only movement is the smoke going up.

CC: Of course, I have a feeling that nothing is really static anyway. I suppose physically you can always

Philip Guston, *Untitled [Head]*, 1975. Ink on paper, 19 × 23½ inches. Private collection.

say there are atoms spinning around, but I like to think about geological time. Slow erosion, gradual moving of strata of rocks. Incredibly slow time, to us, because our time . . .

PG: Our time is different.

CC: Yeah, and everything is like that. I was looking at my cat the other day and wondering about the sense of time the cat must have, since it only lives maybe fifteen years or so.

PG: Or less, yeah.

CC: A day must be an incredible expanse of time.

PG: Oh, I see what you mean. Yeah, sure.

CC: To us, it's like 'Ahh, the damn cat came in again, he just went out, why doesn't he . . .?' But to him it's a whole sequence.

PG: That's right. And to us, we can waste days, knowing that we have the span that we do have.

CC: Which is working against yourself, I think.

PG: I know, yeah.

CC: To lay back on that, and we do it all the time.

PG: That's fascinating, yeah.

CC: Another thing, back a ways you were talking about how important those simple lines are. To me it seems like one of your really basic things is line. I mean, just drawing a line.

PG: I agree with you.

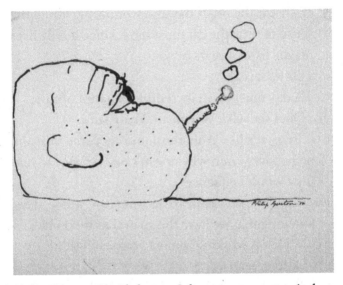

Philip Guston, *Untitled*, 1974. Ink on paper, 14 × 17 inches.
Private collection.

CC: And these new paintings are getting back to line, right?

PG: Well, that's getting back to what you call the bones of the whole damn thing, which *is* line. That's right.

CC: Because the mid-sixties was hardly line. It was mass. You got so into mass that you had one big mass.

PG: Exactly! In fact, I wanted to eliminate line. One of the great excitements of those black, dark pictures in the mid-sixties was to eliminate line, to eliminate contour and work with mass.

CC: Which you had done in drawings in the early fifties.

PG: That's right. And I swung just the other way after that, with line. Well, one of the things about line is that it's the most direct, primitive . . .

CC: It's the mark.

PG: Mark, of a division of space. When you come in the studio, because of the photographs that Steve [Sloman] is going to take, I picked out about twenty-five or thirty of these which you haven't really seen. And some of them are only one line, or at most two lines or three lines, dividing the space. And I realize now that I had to do that, and why I did that.

CC: It's the bones.

PG: It's the bones of the whole thing.

CC: Because you can look at a line and it's fantastically ambiguous, too. At the same time as being the most solid thing you can make, you could see it so many ways. You can see it as a cut, you can see it as a stiff iron, you can see it as a division . . .

PG: Well, at this point, however, I must say something about that year of drawing, when I did hundreds, literally, maybe even into the thousands.

CC: In Florida, right?

PG: That's right. And up here.

CC: It strikes me funny that that was in Florida.

PG: I know. Well, for many reasons that we don't have to go into now, I was cut off, you know.

CC: I know. And it's because I always think of Florida as a good-for-nothing place.

PG: It is! That's exactly what it is. It's nothing.

CC: Where rich people go to do nothing.

PG: I know. It's just a nothing place.

CC: And you go there and you do *that*.

PG: I know. Well, I didn't work there for some weeks or months and then finally, out of desperation, I started this. And, in fact, when I was doing these

line things, I suddenly got a call from [Morton] Feldman, who was in Texas making that show for the de Menils, in Dallas? Or Houston, I guess it was. And he said, 'I'm in Texas, come and see me.' No. He said, 'Can I come to see you?' And I said, 'Please come.' He said, 'What are you doing?' I said, 'I'm down to one line.' And he said, 'I'm coming right away.' And he appeared two days later. I met him at the airport and I showed him all these things. They were all over the walls, the floor. The whole studio was just bulging, hung with these drawings. They were just brush ink on paper. They were all over the floor – you couldn't walk in. So we looked at them. And that night, after dinner, we took a walk along the beach, and I started kind of weeping. Not weeping but sort of shaking. And I said, 'Well, I'm really down to nothing now. I'm just down to, like, one line.' I mean, there were literally dozens of drawings with just one line. And, you know, Feldman always has a kind of obtuse way of talking, and he said that the last great trick of Houdini's was to put himself in a trunk, the trunk was locked, the key was thrown away, and they threw the trunk over the Brooklyn Bridge into the river. You remember that famous trick?

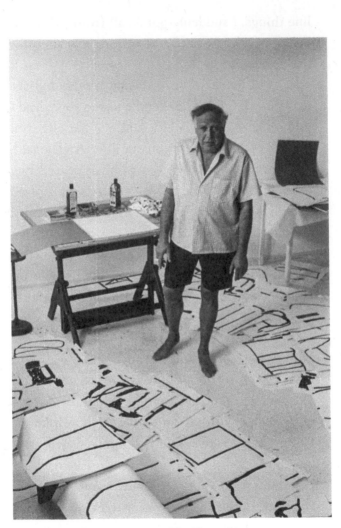
Guston drawing in Sarasota, Florida, 1967.

CC: Yeah.

PG: So he told me that story. And that was all I needed to hear, that story.

CC: What does *that* mean?

PG: Well, he said that's exactly the state, the situation you're in.

CC: Wow. But I bet he secretly loved that ... simplicity.

PG: Well, that's Feldman. Anyway, look what happened from that line. But here's what I want to tell you about that. You know, you do things and then you get critical and you become not so enchanted with the gesture any more, and you begin seeing what it's doing in the whole field. And the ones that were thrown away were where they were just lines. Who the hell wants lines? Any more than you want mass or color. I mean, they talk about color field painting as if we're all panting and hungry for color. Who needs color? Or who needs line? Who needs anything?

CC: Right.

PG: What you want is ... something. This enigma is what you want, this mystery. Right?

CC: By any means.

PG: By *any* means. So that the ones that worked and that I kept, and by *worked* I mean kept on exciting

me, kept on vibrating, kept on moving, were the ones where it is not just line. When it becomes a double activity. That is, when the line defines a space and the space defines the line, there you're somewhere.

CC: Right. And that's not balance or anything.

PG: Not at all, but that's the mysterious part. So this was just as mysterious to me as an eight-foot painting. I mean, this one line on the right is gently pushing that other line. The second line feels like a wind is blowing it into a totally open space.

CC: Right. Or partially open.

PG: Yeah, I mean partially open space, that's right. You mean, it's defined as to where it's going to go, that one line?

CC: Well, it's just breaking loose, too.

PG: Breaking loose.

CC: You got it at the moment of detachment.

PG: That's right. Exactly. It's like in physics, an elaborate concept could be contained in a simple symbol, you know?

CC: Yeah.

PG: That's like a symbol of a very elaborate system there.

CC: Like an infinity sign.

PG: Exactly.

CC: It's ridiculous.

PG: Exactly. Exactly.

CC: I mean, there's something endlessly . . .

PG: Which has to do with that area being open all around.

CC: It's just an endless action.

PG: That's right.

CC: Because it never stops.

PG: It keeps renewing itself. But then, you see, that same phenomenon can happen with a more tangible . . .

CC: Ah!

PG: . . . form. This is what I wanted. Now, I may be all wrong. Maybe the whole thing is a catastrophe, and there are many days of doubts as to whether I should have stuck with that other thing. I mean, there have been people in this house who said, 'Why did you leave that?' But the idea of just staying with that kind of disgusts me. If I had stayed with that, what was I going to do – make a show or a whole aesthetic out of that? I think I wanted to know whether with objects in the real world, just as we talked about, everyday objects, whether that phenomenon isn't true there, too. Well, then what's the difference between that book and that [one-line drawing]?

Philip Guston, *Statement*, 1968. Charcoal on paper, 17½ × 23 inches. Private collection.

You tell me. It's not doing that, is it? Well, what is it doing? And is one better than another? Is one more valuable than another?

CC: You know what happens: You look at it and you make an identification in your mind.

PG: A recognition.

CC: Yeah. And you do it with anything. You try to make it identified. You try to name it, and when you do that it's not interesting to me. I mean, the moment where it's identified is like a shrug. But what's going on after that, after that's happened, the way the thing won't die, you know what I mean? The way it won't just stay a name. It'll keep on going like you said, the vibration. Then, I think it's doing the same thing *that's* doing.

PG: You do?

CC: Yeah, it doesn't matter. Well, not exactly the same thing.

PG: I don't mean just optically.

CC: No, I don't mean that either. But what makes it vibrate? What keeps you looking at it?

PG: Well, this [book] is more mysterious to me than that [one line].

CC: What kept you looking at it long enough to paint it? What makes that more interesting than just a book? In other words, you said, 'Paint a book,' and

you went like this *[shapes rectangle in air]*. So what? You obviously didn't just do that. You said: 'Each one of those little things is a whole world.'

PG: Yeah, the writing in there.

CC: Okay, that's that act, which has a similarity to this act. I'm just talking about process now. But you're going to say: 'Yeah, but how come I'm more interested in that?'

PG: How come I'm more interested in that than this?

CC: That's what I'm trying to . . .

PG: This has been going on now for five years, and I'm just as puzzled by that. Why couldn't I have stayed with that? These lines, this reduction.

CC: I think it has to do with a sense of tangibility and physicality.

PG: Can you enlarge on that?

CC: Well, I had this thing I thought of where for some reason it seemed to me that I got a stronger feeling of the paint as material from looking at a painted image rather than a less defined one. And that seemed to me odd. Why? It would seem like the paintings of the mid-sixties would leave you with paint, with material, a lot stronger. But the more I look at these, like that little book you gave me. I've got it in front of my typewriter.

PG: You wrote something wonderful in a letter to me once about that book.

CC: What was that?

PG: Well, to paraphrase you, you said that you're constantly mystified by how a mark or marks become an image.

CC: That's what I'm trying to get at. It's like we want to be *all* of our work. We want to bring to bear everything. You want the *name* and the thing.

PG: Sure.

CC: And the movement. That's still vaguer than I want to say, but it just seemed that the longer I looked at that book the more I was aware of it as a book and as paint. Equally, maybe.

PG: To go back for a minute, one thing you just said in talking about that book, that the recognition puts you off: book, shrug, so what? But then, after the recognition, come all these other feelings. Well, what I think, in my own back and forth between the pure thing, the essence thing, and the figurative thing, that tangible object, is this: it's as if I want a mask. And I think this is important, significant. I've thought so much about it, that one of the difficulties with this essence thing is that it is not hidden.

CC: Too open?

PG: It's too open and too evident, for me.

CC: Okay, well, what about artifice then?

PG: Well, wait a minute before you use the word *artifice*. It seems to me that when you paint an object, when you talk about the recognition, a significant value or ingredient is the hidden and the masked. And what I mean exactly is this: Now, all good painting, and I think my painting is good, has always dealt with forces. But that's a generalized statement. By *forces* I mean you're dealing with movement and magnetism. The magnetic pulls of one form on another. The things which happen in the spatial field that separate. And also the psychological overtones and so on. All right. Now, it seems to me that an important ingredient here is that I don't think we want those forces to be so evident to us, that when they are somewhat masked they seem to last longer for me. In fact, I think that's where the enigma is, in the hidden. And when it is not as hidden, there are hidden things there, too. It's not an either/or situation. I think the reason I couldn't live too long in that place of that essence thing is that what was happening was too immediately evident to me. So I thought, well, okay, so I'm not a modern artist. I can live with that, too.

Modern art being that which is most direct, most evident. It speaks to you with nothing hidden, everything exposed. I mean, modern art has to do with . . .

cc: Taking things apart?

pg: Taking things apart and exposing. And traditional art, the art of the past, is a hidden art. And it could be that, temperamentally, the source of my difficulty here, if it is a difficulty, is a constant pulling, veering, between exposing and hiding.

cc: Well, there's another one of those polarities.

pg: That could be. Because I think a guy like Philip Pearlstein doesn't have a problem. He just paints those stupid elbows and knees. I mean, I'm not talking about realistic painting. But when a formal painter like myself starts dealing with objects, these elements do come into it. And by the way, it just occurs to me that one of the reasons for the resistance to my recent work was that it couldn't be placed easily. That is to say, it was neither abstract nor figurative. 'If it's figurative,' many critics wrote, 'why doesn't he paint the way things are and look, like Pearlstein or Alex Katz?' But you know, if you deal with objects with a great heightened sense of form, of forces and abstractions of forces,

you've got something that looks mighty peculiar.

CC: Right. That's why I said that thing about recognition, because you can recognize that [one line] as something, too. Not as an image but as a certain kind of art. I mean, you can have that flicker and say, 'Ah, that's . . .'

PG: That bothers me. That bothers me.

CC: I must say, though, Philip, that goes beyond that, and you know it, too.

PG: Yes. I know that, too.

CC: But let's not get off the argument. You've got something good going here.

PG: You mean about the hidden?

CC: The exposed and the hidden.

PG: Well, then if you deal with objects, you are hiding . . .

CC: Those artists of the past believed in spirits and gods and magic, right? More than we do. We're a pragmatic age. We've got this fucked-up Greenbergian take-it-apart school. So, here's a guy who just does the backgrounds; he's a color field painter. And here's a guy who makes actual objects.

PG: This is great. We never talked this way about it. But you see, to me, and I think to you, too, art is

still a primitive magic. And the artists of the past believed in art as magic and art as exorcising, et cetera. In other words, this was the original function of art anyway, from the caves onward.

CC: The spoken word, too.

PG: And the spoken word, too. So that it seems to me the only hope for art, at least the only thing that excites me and makes my heart go pitter-pat, is the magic, the imagery. At dinner you were talking about Melville, *Moby Dick*. Well, for God's sake, I mean, as you said, that's a cosmos there, no? The whole thing is about magic.

CC: You know what's interesting about that book, too, is that in that book he believed in Jehovah. He believed in the Shrouded of Ages, or whatever you call it. Only at the end of his life he weakened and took up what Olson called the soft hermaphroditical Christs of his later work.* Like a man going down the drain, you know? But before that, he had the fucking forces of the world in his hand. The pyramids. Did you ever read that magnificent description of the pyramids that he wrote?

* Charles Olson, *Collected Prose* (Berkeley: University of California Press, 1997), 90.

PG: No.

CC: It's in a notebook. He said they neither seemed to have been built by man or God.*

PG: Isn't that fantastic?

CC: He said the more you look at them ... And there's the enigma.

PG: Well, that is the enigma!

CC: He absolutely put his finger on it.

PG: That's the riddle of the sphinx.

CC: You see, and let me just take it into words for a second. There's the recognition of naming with words, which has become so facile that it's the shrug. I mean, we're in an information age. What we want from words is the information. To me, the word is magic. If you say *book* and then you keep looking at the word, or sounding the word in your mind, you realize that the word has a lot of qualities that aren't just a matter of a simple exchange, you know what I mean? In early times, we're told that there were only certain men who were allowed to speak certain words, because those words were absolutely evocations of

* 'Man seems to have had as little to do with it as Nature.' Herman Melville, *Journals* (Evanston: Northwestern University Press, 1989), 78.

something that only existed at that moment. They had this magic quality. And that's what I want to get.

PG: I feel so much what you're saying. That's what I want, an image to contain that, to be as fraught with that danger and evocation and risk.

CC: We don't even know what it is, right?

PG: No. But, it seems to me, that's the only hope for art now. Otherwise it can just be information art.

CC: Absolutely. And that's what most of it is now.

PG: You see? Or optical art or . . .

CC: I mean, back to words, an art that you can call, that you can name and shrug off. This art, that art, all those little modules.

PG: There's something else that fascinates me, and I've thought a lot about this: that when movement substitutes itself as a form, that's fascinating. That is to say, it puts on clothes, so to speak, becomes bodied, rather than disembodied.

CC: Right. Like that book picture. There's a kind of graspability factor that should be brought up, too, which isn't just a matter of identification.

PG: It has to do with kinesthesia. It has to do with being blind. I mean, I wanted that book to feel as if you were blind in a dark room and you came in

and you felt an object. How would you paint something that you only felt with your hands?

CC: Painting a book in the dark.

PG: Yeah. Or you grab that paw and feel its pulpiness, or its tendon, or whatever you'd feel. So, it's not just a noun, not just recognition.

CC: You know what, though? The words themselves are masks. That's another interesting thing.

PG: Yeah, tell me about that.

CC: The word *book*, let's just say that. What has that got to do with the real book really?

PG: No. It's a separate thing.

CC: It's booooook. Like in Beckett's *Krapp's Last Tape*, he takes the spool of tape and he says, 'spoooooool', and he says it over and over again, so it's like an incantation.

PG: You're talking about the space between the thing and the word, which we have invented.

CC: Yeah. When we're naming something we're really masking it, in a sense.

PG: Of course you are.

CC: Because we're using this word which doesn't relate to it, except by acceptance of a meaning. But this thing, this mask, what is it? It's absolutely fascinating.

PG: Well, then would you say art is a mask?

CC: Yeah.

PG: Art *is* a mask.

CC: Very strong. Yeah.

PG: And furthermore, to confound this more, frustration is a very crucial ingredient here. The frustration of not being able to make them identical. That is to say, the word *book* is not the book, because you can feel the book and tear it or cut it, squash it or crumple it. But *book* is a word. And so my painting of an object has to do with the frustration of not being able to paint the object, either.

CC: Which, to further confound it, isn't what you want to do anyway.

PG: Of course not. I know it. But I would say that the frustration is a crucial ingredient here.

CC: Absolutely. That's the resistance.

PG: It's the resistance. It's the frustration of the desire to not paint altogether. That is to say, art is the frustration of the desire *not* to make art, you know?

CC: Wow. I've got to hear that, myself.

PG: And the trouble with that . . . I've had my lonely winter nights worrying about that, those two lines . . .

CC: That *is* the desire to make art.

165

PG: That's right. And that's why I had to give it up. That makes art too available to me. And that's where my fight with Feldman is, and he knows it and that's why he won't call me. He wants me to do *that.*

CC: Well, that's what I meant. He loved that, right?

PG: That's right. And he wants art.

CC: You were in hell, and he was loving that.

PG: He was loving it. And he wants art. And I don't want to be an artist really. But I am and I'm going to be and I want to make these forms.

CC: Well, that's what you said in your letter, 'the irresponsibility to art'.

PG: That's right. And talk about Melville, boy, he burst those bounds.

CC: He was illegal for all time.

PG: That's right. He was somewhere else.

CC: I mean, no wonder nobody liked it. It was a punch in the mouth.

PG: Well, you're not supposed to burst the limits of art.

CC: He was supposed to write travelogues.

PG: He was supposed to make literature.

CC: You're not supposed to be able to create.

PG: That's right.

CC: It's like the original sin.

PG: Exactly.

CC: Don't touch it.

PG: That's right.

CC: Boy, this goes a long ways.

PG: You know, I never thought of it before. I've got to hear this again. Why don't we have ourselves a drink?

CC: Okay. We're about to the end of the tape anyway.

PG: Just let it run out.

CC: I have the feeling I've dealt with these things but I haven't thought about some of them, you know what I mean? I guess you feel that way, too.

PG: Sure. Well, you talk about discontent . . . I think discontent precisely has to do with, and I guess I must put it sort of blatantly, it has to do with the disgust with art.

CC: Yeah.

PG: I think the greatness of Beckett, really, is that deep and lifelong profound disgust with art. And, paradoxically, that's why he became a great artist. But if you go into this devil's work, and it is a devil's work, there's no insurance you're going to come out.

CC: Yeah. Right.

PG: And the reason that there are hundreds and thousands of good, safe artists is because there's

a threshold which some are perhaps aware of, others not. And those that are aware of it don't want to pass that threshold.

CC: That's why I say, it's not that I'm so discontented with my friends who are poets. I'm just discontented.

PG: Yes, I know what you mean.

CC: And therefore I'm discontented with their lack of discontent.

PG: Of course.

CC: I feel like: *I'm* discontented, what's the matter with you guys?

PG: Yeah. Why aren't *you* discontented?

CC: What did you say, 'devil's work'? You know what Melville said, that famous quote? He wrote to Hawthorne, after he'd finished *Moby Dick,* and he said, 'I've written an evil book . . .'

PG: No!

CC: '. . . and feel spotless as a lamb.'*

PG: Oh, that's fantastic! As *spotless* as a lamb.

CC: Yeah, he saved himself somehow.

PG: That's right. That's marvelous.

* 'I have written a wicked book, and feel spotless as a lamb.' Herman Melville, *Correspondence* (Evanston: Northwestern University Press, 1993), 212.

CC: He went there and he came back. It's like going into a deep psychosis and coming out.

PG: I know just what that feeling is. Oh, that's marvelous.

CC: Which is what [R. D.] Laing and those guys believe, that you go through your psychosis. You go all the way into it and you come out. You don't try to stop it with psychoanalysis or drugs or something. You go through.

PG: Well, isn't that true? Like we once talked about, artists who settle somewhere. I once made an analogy that, in painting, creating, it's a court. But unlike a court, you're the plaintiff, the defendant, the lawyer, the judge, and the jury. And most artists want to settle outside of court. No trial.

CC: It's a perfect image, because that's how you do make money in court, you settle out. If you don't, you lose all your money in the process.

PG: That's right. Well, in Italian, trial is *processo*. It's called process. Or in German, it's *prozess*. And in French, it's *procès*. The trial is process.

CC: Sure. I suppose that's even true in English. Like trial by fire. Going through something.

PG: Going through, sure. So that Kafka's book in Italian would be called *Il Processo*.

CC: Fantastic.

PG: Yeah. *[laughter]*

CC: That all makes sense. It's perfect.

PG: I like what you said about Laing. How some people, in going into psychoanalysis, prefer to stop.

CC: Treat symptoms.

PG: Sure.

CC: That's what our medicine is all about.

PG: Is to stop somewhere.

CC: Float. Float for the rest of your life.

TEN DRAWINGS*
1973

* This statement accompanied a set of ten drawings.

It is the bareness of drawing that I like. The act of drawing is what locates, suggests, discovers. At times it seems enough to draw, without the distractions of color and mass. Yet it is an old ambition to make drawing and painting one.

Usually, I draw in relation to my painting, what I am working on at the time. On a lucky day a surprising balance of forms and spaces will appear and I feel the drawing making itself, the image taking hold. This in turn moves me toward painting – anxious to get to the same place, with the actuality of paint and light.

ON DRAWING*
1974

PHILIP GUSTON: In former summers I've brought up slides of paintings. I would show a progression of them, and so on. But I didn't do that this time, mainly because I didn't want to bore some of the staff who are with us again. So I wanted to bring up things they'd never seen, which are drawings. And in selecting the slides, of the photos that I had slides made of, I didn't know where to stop. I thought, well, I'll start with 1960. Then I said, Well, no, I'll go to 1950. And then I went all the way back to when I was about seventeen years old. So I thought, maybe they'll be like a retrospective, which is what this is. I'm going to show you what I drew like when I was seventeen years old. It's a risky thing to do, but there it is. I mean, it's what I did. And then I think drawings are exciting to look at. The art books I have, of the masters, are mostly drawings. I seem to tend to buy books of drawings. Because, of course, you

see the most intimate thought, all his reflections, his erasures, the direct impulse. It's not paint. We all know that with paint you put down a pink, a red, a blue, a shape, and you scumble it over, you change it. There's a lot of funny business going on in painting. But drawing is direct.

Now, most of the time, except for the very early drawings, they're not studies for paintings. They're meant to be like complete drawings in themselves, as you'll see. But from about the late forties on, I drew a lot but not as complete drawings. You know what I mean by that? It sounds funny. I mean, the drawings were germinating ideas always in relation to what I was painting at that time. So that my habit of working all through the fifties and sixties and now is: I won't paint for a week or a few days. I buy paper by the ream, the big butcher-block drawing paper. And I use either charcoal or ink. Something direct. In fact, I like charcoal because charcoal is a mess. You can't ever really fix charcoal, but who cares? It's like an extension of your finger, you know what I mean? You don't have to stop to pick up ink, which is always a drag. The idea is: Don't stop. So, I'll draw. And they're goofy drawings. I mean, just

searching, searching, searching, and they're germinating. My painting comes out of drawing. I couldn't live without drawing. I know that. It's constant. You scribble. You draw. Okay.

My intention in drawing throughout the years kept changing. It was always in relation to the painting. Well, we'll talk more directly about what we're dealing with here.

There are gaps. Well, I don't want to go into autobiography too much, but even this was in relation to what I was painting then. I was about seventeen when I did this [drawing for *Conspirators*]. I was doing some large paintings of the Ku Klux Klan, which was very active in Los Angeles where I was reared. But this is simply pencil, which I like to draw with, on two- or three-ply Strathmore with a little pink for the bricks. So that's how I drew then. It was way back in the early thirties.

Several paintings came out of this drawing. Now, in this early work I don't have photos of lots of drawings. So there are going to be jumps. For instance, between this drawing and that I'd say is about five years. A self-portrait.

Very Renaissance-influenced, very involved with the modeling of forms. Hard and severe as I

Philip Guston, *Untitled (Self Portrait)*. 1937. Pencil on paper,
18⅜ × 13 inches. Private collection.

could, as three-dimensional as I could make it. Now, we've jumped – again, a five-year jump. A portrait of a friend of mine. Again, pencil on Strathmore. And things have changed for me somewhat. I did many drawings in this softer mode. I was very influenced by Picasso's classical period, Corot drawings, Ingres of course. And I suppose I don't have to tell you: you work from what you're seeing, but you don't draw everything you see. You evolve a highly selective process. You fight for that contour, of course, and so on. A drawing very involved with the feel of hair, the actual texture, the tactile quality of hair as well as skin.

Well, it's a big jump here. Again, about eight years. And you'll have to accept it. But from here on, they follow pretty much year by year. So things had changed for me. This was a drawing from about 1948, 1949, something like that. I had been doing lots of imaginary paintings of children in masquerades and so on. And about 1948, I lost interest in it. I mean, I just couldn't continue. And figuration itself seemed to slip away from me. I was also friendly and close to certain painters whose names you now know, who were roughly called the New York School. And they were going through the same kind of a process of change.

Philip Guston, *Sarah*, 1944. Pencil on paper. 19¼ × 14¼ inches.
Private collection.

Philip Guston, *Self-portrait*, 1946. Brush and ink on paper,
13⅞ × 11 inches. Private collection.

And we were friends. I mean painters like Bradley Tomlin and Brooks, de Kooning, Kline. Well, others. And I was beginning to feel that painting should be more of an exploration and a radical change. Of course, being in that group, I shared the electric atmosphere at the time.

But this was done when I went to Europe for the first time. I went to Italy for the first time in 1948 and I didn't paint for that whole year. I just traveled and drew out of hotel windows. And this drawing [Drawing No. 2 (Ischia)] actually was done on the beach of a little island in the Bay of Naples called Ischia. It's a drawing of the town, just looking at the complex of the town. Little white buildings and black windows, done with just a reed I found on the beach, with my bottle of ink. It's strange how something done offhand like this can lead to painting, you know, like a seed. This led me into a whole period of painting, all through the early fifties. I wish I'd brought slides along. And then I began drawing very freely and loosely, scribbling. That's 1950, roughly working from a still life.* One of my intentions at that

* Possibly the untitled ink drawing no. 9, 1950, in *Philip Guston: Works on Paper*, exh. cat. (New York: Morgan

time, and it still is to some extent but very strongly at that time, was to attack the paper with a stick, with the stuff, the ink, with as little preconception as possible. That is, actually not knowing. Just a feeling, like some instinctual feeling, like you just want to make marks. You don't know where it's going to go, how it's going to turn out. I can only tell you how I felt at the time, which I think is a valid thing to do. I can't look at a drawing and say: Look how I handled this area. That's foolish.

So that is how I felt. I would do hundreds of drawings a week and maybe get two or three out of it that I could live with, that I could tolerate. Why did I do that? I wanted to test myself. I remember thinking a great deal that maybe I don't know what I think I know about structure and order and unity. You know, some kind of organic unity. I would sense all these things in the drawings that I loved, the notebook drawings of the masters I loved, but I couldn't work like that, I wasn't living then. I didn't have that subject. I had no subject. Only the subject of my

Library and Museum, 2008), viewable online at www. themorgan.org/sites/default/files/pdf/press/Guston Checklist.pdf.

instinct, my urges. I didn't know how it was going to turn out, so I wanted to test myself and see what would happen. Even the decision, like at the end of a week of doing hundreds of drawings, for example, putting them all up around the wall, even the difficulty of deciding which is good or which is working and which doesn't, is hair-raising. I mean, that in itself was part of the process. But I did know certain things that I wanted, still want and like and respond to. You see, now I can be more analytical about it than I was then. When you're doing something, you're not, but past tense you can do it. I did know that I wanted to feel the whole field, the whole rectangle, the whole area, the world! That's the world, that's your world. Alive. I didn't want to feel that I was just making marks on the surface. In fact, there had to be a certain kind of balance, equilibrium, between the line and the spaces, the white, so that neither gained, if you know what I mean. And by the way, most of these drawings, in case you're interested, are done with those bamboo sticks, those Chinese or Japanese sticks. I just cut a slit in them and they hold a lot of ink. Then you turn it and it makes a different kind of line.

I did include a few paintings in this slide talk, only to show some relationship between what was going on in the drawings and the paintings. That's a painting done in the same year, 1951 or 1950 [probably *White Painting*, 1951]. And as with the previous couple of drawings, I decided I would attack the canvas like a drawing. It's still my ambition, in a way, to treat a painting with the same ease. I didn't have much money then, and I wanted to be able to buy reams of canvas, like hundreds of rolls, stick them up on the wall like you would paper. Go through fifty yards and maybe get one or two pictures out of it. And I treated this painting like a drawing, done in an hour or something like that. And I thought of it so much in that sense that I didn't even have an easel. I just put the canvas on the wall and had a big hunk of glass with the paint on it. Usually it's by your side. I had destroyed some pictures previous to that because it took too long to get to the side to pick up the paint. So I put the palette in front of me, in front of the piece of linen, so I could just pick it up and put it on without stepping back. I didn't want to step back to look. That was about an hour's work and I was to go somewhere with somebody and they honked the horn, so I went and I came back a

day or two later and it looked fine. It looked okay. But this was a crucial painting for me. In the sense that I began to feel that I could really learn, investigate, by losing a lot of what I knew. Of course later I discovered that I wasn't losing. I don't know if I was gaining. Hopefully, gaining. But to reiterate that remark I made before, I began to feel that maybe I didn't know what I thought I knew. And that induced a willingness to risk and follow urges, instincts. You know, we kill those instincts, don't we? You start thinking about composition and so on. I mean, nobody tells you to put a line here and a line there. How do you know? You're plunging. The sensation you have is that you're plunging into space, like jumping off the Grand Canyon or something. You don't know how it's going to turn out. I still do that.

I guess we'll have to treat this as if we're just going through a big retrospective show of drawings, because that's what it is. I don't know what to say about each one, except there it is and I like it and that's the one that survived after my eyes' testing it over the years.

AUDIENCE: *[inaudible]*

PG: I know what you mean, but I don't know how to answer that. I live in the world. I look, I see things

move, I'm aware of forces, equilibriums. Maybe I misunderstood you. You mean, actually looking at something?

AUD: *[inaudible]*

PG: No, I'd never do that. That's a bore.

AUD: *[inaudible]*

PG: Well, I mean vaguely. I mean imaginary. Yeah. I've spent years drawing from things. People, figures, and so on. But I think I'm aware, if it's possible to answer that a little more, of forces that are at work. I mean, if I see wind blowing through a tree and I see the way the leaves move . . . I remember I used to like to lie down, like when you go on a picnic or something, and watch people walk, and I'd think, 'Isn't that strange the way they locomote? How one foot moves.' I think I'm in love with forces of things. What causes this to move and that to move and so on. What were you going to ask?

AUD: *[inaudible]*

PG: It's more complicated than that. I don't want to sound complicated. I mean to say, it's not as simple as that. That is to say, there's figuration in everything. We all look at spots, blotches, dots, and see things. That's a natural activity. So that there seems to me to be an interaction going on between you and it. You put some marks down on

the paper, and at the moment that you're putting those marks down they're not just marks. I don't know what they are, but they're not just marks. Because when you put down a mark and you put down another mark, something is happening in the spaces between those several marks or movements. What are you asking me? Whether I put down the marks first and then see, or whether I see first and put down the marks? Is that what you mean? Huh? Both. Is that what you're asking?

AUD: Yeah. What impulse drives you to, or allows you to, put the marks in one place on the page instead of another? Do you close your eyes and . . .

PG: No. I think we're talking about spontaneity. That's a cryptic word. I don't even know what spontaneity is, actually. First of all, one experience comes out of another. One work comes out of another work. It's a series, it's a chain, right? Drawing and painting is a chain of events.

AUD: *[inaudible]*

PG: I beg your pardon? Is this Gabriel? Yes?

AUD: *[inaudible]*

PG: A little bit like Louis [Finkelstein] did. In a sense of closely analyzing what it is that happened to me.

AUD: *[inaudible]*

PG: Sure. Yeah. Well, in that sense . . . who?

AUD: *[inaudible]*

PG: But you know what the real answer to Gabriel is, what he said? It's what I've often told Louis over years of talking, is that I don't want to know. Who the hell wants to know? Because if I know, I don't want to do, make. Making. This is a constant fight with Louis. Making is knowing, so if I know . . . You see, I don't even want to talk about it right now. I don't even want to talk about what I *don't* want to talk about! Because there's something enervating about knowing.

You see, I think that creating is a double process. You have to be sophisticated as hell and innocent as hell at the same time. It's a real impossibility, but I think that's what it is. And I think that's what all the great ones would say, too. That's my theory. I'm really answering your question in a real sense, I think. No? So if you ask me what happens, do I think first and make a mark or make a mark and then think? I'm having a baby. I don't want to know that much about it. I just want to have that baby, you know what I mean?

AUD: *[inaudible]*

PG: That's a little better. That's a little more prac- tical question. Because, let's say you spend ten, fifteen minutes on this, and as it's getting going there's a growing feeling that something's there, it's happening, this is it. Your heart starts patting, your face gets a little red. You know it's getting there. So then you'll do certain things, coming from knowledge of the strength of the drawing, to make it more this or more that. That's more of a realistic practical question. The other bugs you.

That's a good drawing. I didn't know that was going to happen. And that turns out to be a very structured firm little drawing. Quivering, some- thing quivering through the whole thing.

AUD: When you make the first line on paper, does the quality of that line influence where and how you make . . .

PG: Does it influence me? Sure it does. Because you make a couple of lines, whatever's in your mind, and you're aware that you're setting off some energies there. You're very aware of that. And that can lead you to another movement, another line. Is that what you mean? Yes, it does. But even there you don't know what the total is going to be. And that's what I'm talking about, that this whole period was, for me, one of not knowing.

Where weights and densities and pressures, all that stuff. Not knowing.

AUD: One time you were giving informative crit and we were all up in a room with all these big image paintings and Stephen [Greene?] said something that I always felt was very close to what you said.

PG: Whose painting was this? His?

AUD: Yes, it was his. And he said that the feeling he had afterwards was that he had never known anything about it, except when he saw it he knew that it was the painting that he had wanted to paint.

PG: Yeah, that's right. That's very nicely put. Exactly. But that's after it's done, you see? That's what I meant. I put it another way. I'll try to use more everyday terms. Like what I meant when I said that I didn't think I knew what I thought I knew. Obviously, what that implies is getting rid of habits. And the strange thing, in relation to what you just said, is that when you're willing – willing! – to make a jump and make things strange to yourself, the paradox is that afterwards you find out that that's what it was you wanted to see all the time. That.

Now, at this point I wanted to draw in masses, like losing contour. Sometimes I like to work with contour, like defining a shape. But that time in the

painting itself, around 1954, I was just working with big masses of color. Pinks and reds and so on. And sometimes I like to do just the opposite, work with line and contour.

AUD: How do you know that this is the last line you're going to make?

PG: Yeah. You know.

AUD: How can you be so intellectual about questioning?

PG: You see, all these questions about how do I know and where I make the next line, it's just the opposite of what I'm talking about. I'm talking about engaging in this encounter with *not* knowing. Jesus! And you're talking about 'how will I know.' You still want to know how to make a picture. I'm not talking about making a picture. I'm talking about having an experience.

AUD: It seems to me like the process you're talking about comes after you've finished something.

AUD (2): There is this intellectual side of art.

PG: No one's saying there isn't. Who?

AUD (2): Aristotle and maybe Thomas Aquinas, who were never able to divide the faculties of intellect and emotions as separate things. No one can find them in specific locations in the brain. So, if one is involved in an emotional process, one

is necessarily also involved in an intellectual process.

PG: Sure. But this is not only an emotional process, it's also a process that involves matter. By *matter* I mean ink, paper, space, and spatial divisions. It's matter. You see, I'm in love with painting and drawing, and the great thing about painting and drawing, as opposed to thinking about it, is the resistance of matter. And what I've found over the years in going around and talking with painters or people who are more philosophically inclined, on aesthetics and so on, is that thinking is too free. I mean, boy, it's like a spaceship. You're like a space cadet. You can move everywhere freely. Boom! You can zoom all around. As soon as a guy proposes a thought, you propose the opposite and you get very involved in all kinds of sophistries and interesting philosophical and speculative thought, and it's interesting. But I think the difference between a philosopher or an aesthetician and a painter, and I guess it's also true with a poet and with a man who works with sound, is that the moment you use the stuff there's a commitment, a resistance, where you're not so free. And paradoxically, when you can only do this and not that, in order to move it over

an inch and not two miles, you're more free in some mysterious metaphysical way. You don't have so many choices. So I'm a great believer in matter, in the material. For me, it's all personal. Speculation about what I've done always seems to come later. I always get snarled up.

When I did this, in the middle–late fifties, I was becoming interested in using organic forms, not just marks any more. I wanted things moving into things, like trees and so on. If I stopped and thought, 'Well, there's an interesting exciting area, let's see what it is I did' – Jesus, I couldn't work. Other people may work differently. I'm not at all making a claim that this is the way to work. I'm not proposing a methodology or an aesthetic. I just mean that I have a tendency to analyze. And I know that when I start analyzing too much and start painting in my mind, I find I don't paint. So much. Or I get stuck. I don't like what I do. And I get disgusted with the whole business. And then I start liking to smell the paint. I'll take titanium white, which is the white I use, and even when I don't want to paint I've gone in the studio and I'll just take white and I'll take cadmium red medium, which is my favorite color, and mix it up and make a pink. That mess of pink makes me want to

paint. I put it on and suddenly I stop thinking. And I like to think about painting, naturally. I look at the masters I love and I think about it. Well, what can I do?

I'll tell you what it is. What bores me is to see an illustration of my thought. That would bore me. I want to make something I never saw before and be changed by it. So that I go in the studio and I see these things up and I think, Jesus, did I do that? What a strange thing. And I like to feel strange. It's a personality thing. I like to feel strange to myself. The whole world's filled with things I know. But then, in working more with things, they don't have nouns, they don't have names, but they're things. Things get squashed, are pushing each other, and all that. I like that feeling. Things dent each other, they affect each other. So, when do I know I'm finished? It's when the drawing isn't padded. That is, it's not repaired or tickled. And where the line is alive. Where the line is making the form at the moment of the doing of it. I enjoy the feeling of the thing being caught at a very special certain moment. At a split-second moment the thing is caught, like it just came into existence. And it's about to change into something else, by the way. It's about to

Philip Guston, *The Scale*, 1965. Pen and ink on paper, 18¼ × 24¼ inches. Private collection.

metamorphose into something else. I enjoy that. I don't like waxworks, for instance. You know, convictions about what I like. One could give a talk called 'What I Love and What I Hate'. Generalizations are terrible in art.

So. We're in about the middle sixties here. We're going along. About this time, 1966, I had a show at the Jewish Museum of pictures with just black and white and gray. I'd eliminated colors. Maybe a little bit of pink or something. But generally I was involved with just locating single forms, two heads or two objects, on the canvas.

I like that drawing a lot *[The Scale]*. The balancing. That was a surprise. A seesaw. A big heavy thing, naturally he's going to weigh the smaller apple up. I mean, that apple will never get down. How could he? So, in the years 1966 and 1967, right after this show, I didn't paint for about a year and a half. I just drew. And I don't know what I was doing. I wanted to clear the decks. Well, like that. I did literally thousands. I've got about two dozen I'm going to show you. Very spare drawings. Just with the brush and India ink on paper. Well. Bob Reed? I was doing these when I was coming up to Skidmore, and I was telling you I was doing one line. Well, you see. What say?

Philip Guston, *Untitled*, 1967. Brush ink on paper, 18 × 24 inches. Private collection.

REED: The ruler ones.

PG: Well, I was kidding. I didn't really use a ruler. But the successful ones, to me, were the ones where the space felt filled and they weren't just lines. This one is one of my favorites. I have it hanging in the house and I look at it a lot and it's amazing. If you do two roughly vertical lines, the ones that don't work, the ones you throw away, are just lines. But the ones that work are, of course, where there's a double thing going on. I mean, they're lines but they're not lines, because the spaces are brought into operation. And if you ask me: How do I know? I can't answer that, except that in the last analysis it's feeling. You just feel it, and you take your chances right there. I remember when I did this, that horizontal, just like the edge of a box, that horizontal line seemed miles long. It went forever, on and on and on, and I liked that. Then suddenly it stops and goes down. And I felt, well, there's nothing else to do. It's pretty good.

We were living in Florida, in Sarasota. Those are clouds, of course. The strong feeling of doing these was alternating between great exaltation, like I'm sure the Zen Buddhist monk who drew would feel, and feelings of great depression,

terrible depression. Like, my God, I've given everything up. Is this what I do? It's all that's left? And then the next day great exaltation. I mean, absolute vacillation between those two extremes. And the fact that I had those extremes depressed me. Even that depressed me. But then I acquired a tiny little touch of wisdom: Ah, give it all up anyway. It just felt good to pick up ink and make a circle. You start at the right, you see? The line barely touches on the left? You feel good that it meets that line. I mean, what else do you want to do? I may have to go back to this.

That dip on the left and the dangling vertical, the fact that it doesn't go all the way down felt so good to me when I did it. And that's all I knew. That it felt good, it felt right.

Things shrink, swell out. And then I found that all sorts of things can happen. With the most limited means, you know? That was the great lesson. I mean, we're all students and I wanted to know.

That felt real, that dangling line. And then you can't do it again. It's funny. You do it and you think, 'Well, I'll do some more.' But you can't. It only works once. You can only do anything once. Or the first time, that is.

And these are charcoal. That's a mountain near where we are, opposite our house. Treating the charcoal like an extension of your finger, like you're drawing with your finger. I think a number of things were in my mind then, like how it would be if you hadn't seen any art before. What if you were just doing it the first time, what would you do?

About this time, 1967 or 1968, at the turn of the year, I turned to just objects. A glass, a drinking glass. Just things. I thought I had exhausted what I had been doing in the previous year and I started turning just to everyday objects. A leaf. Things in a vase. They're stuck. They can't get away from each other.

It's dangerous to say I looked at this or looked at that. It was winter and I'd been drawing the snow in the snow-covered back field we have there [in Woodstock]. I didn't look at it. You do look at it all the time, but that's not what you're doing. So I suppose there is an influence of the things you see.

That felt good, to do that. That's one of my favorite drawings. It seems very full, the whole page feels full.

Rain. Bug in the rain. *[laughter]*

Well, then, I guess, about 1968 or so I really, the hell with it, I wanted to draw solid stuff. I didn't suddenly do it, you know. But one of the first ones I liked was just a drawing of my inkwell. And that's the bamboo stick you use. It looks like a body laid out. I started drawing things then. An old dilapidated armchair I have. It took a good half-year to get into it. But I'm showing you what I consider the better ones, the ones I like. This is already 1968, and this led into that whole group of paintings. That's what I wanted to show you. There are also hundreds of little paintings that I didn't show. And then I got hipped on books. What was in my mind, I thought I would draw just what was very close to me. I read a lot. You know, you live in the country, so: Books. Lamps. Lightbulbs. Food. Shoes. Just things around me. And I must have done hundreds of books. They're just such a simple form, but it seemed filled with possibilities. I did a telephone book. Oh, you know, they have a drawing in the telephone book, like 'Look in the Yellow Pages with your finger'? And then some of the books started looking like stone tablets. They keep changing. When you draw or paint a form, it metamorphoses. It changes into something else.

Then I wanted to make thick books that look a little bit like in between a building and a grader. But I wanted to make it real solid.

That was a painting which followed a lot of the drawings of books, and I've always loved this painting [possibly *Book*, 1968]. I have it. It's a big gouache, about forty by fifty. And the book was bigger, but it got smaller and smaller. And then I thought, 'Gee, that's just the right size.' You could pick it up. A very tender book.

That's the first painting of the sole of a shoe. But it changes. I don't know what the hell it looks like. It doesn't look like a shoe, but I don't know what.

Then I'd been drawing, for some weeks or months, some Klan figures. I was influenced, of course, like everybody else, very interested and involved politically in what's happening to the country and the world. And this was done at the time of the Chicago convention of 1968. And this is one of the early ones, the early Klan drawings.

That's a painting which I've never shown. And then the eyes started disappearing. They became more slits like that, see? But this was all germinating stuff in relation to that series of paintings. In 1970 I had a large show [at the

Marlborough Gallery] of the theme relating to this. Pictures of big heaped-up bodies and terrible things happening and goings-on. Whipping each other. Beg pardon?

AUD: What made you change your role from not knowing what you were going to get when you finished a drawing to kind of knowing?

PG: Yeah. But you know, I discovered that as I'm going more into what obviously is a figuration, I don't have the illusion that I know what I'm going to do either. I mean, there's even more ambiguity and complication. That was another discovery for me. In fact, at about this time I reversed myself. I'd work for weeks on the drawing for a painting. I really could visualize the whole painting in my mind. And I thought, I want to see if I can do this, like I did in the past, seemingly know what I'm going to project and then start painting. And then when I started the painting, it didn't hold that way. All these changes take place. And then working with not just figuration but with a subject matter, a real subject, almost a narrative subject, you discover that the shifts of forms, spaces, really make you reel. It makes the other way of working almost simple.

AUD: What was your emotional state at this time?

PG: I felt less exclusive. I wanted to include every-thing. I felt, like everybody, disturbed about everything to such an extent that I didn't want to exclude it from the studio, from what I did. Paint it. I didn't think I was illustrating anything. What say?

AUD: Were you ever thinking about having a more inclusive or exclusive audience?

PG: I didn't think about that. I had no illusions that I could ever influence anybody politically. That would be silly. I mean, this is not the medium. Nor the outlet, wherever, when you show them. No. I think the forms became exciting to me, and I wanted to see if I could include those forms in my work. I would make sketches like that, dozens. Start the paintings. Big fighting in the streets. But they changed in the painting, naturally. It goes through many transforma-tions. In fact, I have one or two I brought along to show you what I was painting at the time [for example. *Caught*, 1970]. I conceived of these fig-ures as very pathetic, tattered, full of seams. I don't know how to explain it. Something path-etic about brutality, and comic also. I mean, the mixture of emotions. The guy's gone nuts. Huh?

AUD: You often talk about almost a fear of not being afraid, or a fear of not having something to really grind against. Do you feel that that kind of feeling is a starting point?

PG: Of this particular work? Let me see. You're saying, a fear of not . . .

AUD: Of not having anything to grind against.

PG: A resistance, you mean?

AUD: Yeah. Do you feel that that's a starting point for a lot of these things to go into?

PG: Well, I know when I'm starting these things – talking about not knowing, I guess I should explain that. I know that I'm going to do this kind of figure. I feel this kind of emotion. I know I'm not going to draw two giraffes in the circus. I know I'm going to do this. But in the doing of it, it's also, I find, an exploratory world. And furthermore, I feel it's more my world. It's a place. I think you saw that 1970 work, did you? It's a city, it's a place. That's the bad guy. There's a painting like that. *Sheriff*, I call it. I have them sitting around eating, smoking, plotting. I actually visualized the kind of room they were in. Beg pardon?

AUD: *[inaudible]*

PG: In a different way. I mean, I know I'm dealing with a certain subject, obviously, right? But how

it's going to turn out I don't know. I mean, I did a whole series of drawings like this, but only this one turned out the way I wanted it. Yeah. It's a different process, no doubt. Sure. How can it be the same? I wanted a bunch of lugs getting drunk, smoking cigars. That's what I wanted. Brutes. But part of my own pleasure, in answer to your questions, was not too dissimilar. When it turns out, it's discovery. I don't know how it's going to look.

These are notebook sketches I liked. They all led to paintings. The studio was scattered with, all the walls were just covered with, hundreds of these things. And when I'd paint I would just have an atmosphere of all these drawings. I never followed any one of them literally. But it's curious, isn't it?

That was one of the more successful paintings that happened after a lot of those drawings. That's a forty by sixty canvas. They're just pictures on a wall.

A very sexy lightbulb and book.

AUD: *[inaudible]*

PG: Really? You know, I found when I was doing these pictures that I had made a circle, you might say. All my older interests in painting, the children fighting with garbage cans and all that stuff, very influenced by Uccello and Piero, came

flooding back on me, and I felt like I had so much to handle. I couldn't wait for the next day to start.

AUD: Do you ever think about the paintings that you did of the children?

PG: Oh, you know those?

AUD: Yeah.

PG: Yeah. They've grown up.

AUD: It seems like you've come back to that. But a lot of the drawings stay very consistent.

PG: Well, that was one of the big paintings that came out of a lot of the drawings. I mean, those two. That and the previous one. They're big nine and a half, ten-foot paintings. Huh?

AUD: One thing that seems to have changed, although it doesn't appear particularly in the last show, in comparison to the fifties, was that you used to talk a lot about how you could never get to the outside. How you were always stuck in the middle, trying to push out.

PG: Go to the edges, you mean?

AUD: You're outside all the time now. Why do you feel that happened?

PG: I don't know how to answer that, except that I feel . . . Let's see. Well, let's go on.

That's a recent drawing, which led to some of those recumbent figures that you saw up in the

Boston show last spring.* That was the painting you're referring to. That was one of the larger pictures. It's recent. I just did it last summer, fall.

In some of the work I've done since this show I feel . . . how shall I say? There's a real world I'm painting, that I'm imagining, and it exists. All I have to do is reveal it. I don't even have to search very much. I just have to get in there and reveal it. So it's a real world, a real place. Guys in a bed. Doing this, that. And I don't stop so quickly. I want to realize it. I want to reveal this, you know? Does that make any sense? In the earlier work, say of the fifties, when the feeling stopped, I stopped. Here the feeling is more bound up with tangibilia.

AUD: It had to do with trying to lose contour and lose form. And I think you're going after those forms now.

PG: Oh, yeah, they're very solid.

AUD: They're very real to you.

PG: Very real to me. And hopefully to others. There's an American painter who lives in England, and I'm not crazy about his work but I like him, Ronald Kitaj. He came to Woodstock last

* *Philip Guston: New Paintings*, Boston University School of Fine and Applied Arts Gallery, March 15–April 14, 1974.

fall when I had these pictures all around – I hadn't shipped them to Boston. And there's a whole series of painters, I conceived them as painters in bed. There are very few hooded figures there. One is called *Painting, Smoking, Eating*, and he's imagining this painting or he's making a painting, I don't know. He's just in bed imagining it, smoking, paint can on his chest, some French fries on his chest. There are about a half a dozen of these characters, and I was very pleased with what Kitaj said. He said: 'You know what you've done? You've created a man, you've created a character.' And in some of the paintings I've done since that show, he's there again. Maybe I feel more like a novelist or something. You know, you have to have something to deal with. Painting is kind of boring; it's really tedious, like a job or a lesson or something. But when you have something to deal with, a character or a person, well, then he's got to have an environment. He sleeps, he eats, he paints, he does things. You know, I used to be very interested in Beckmann in the forties. I used to love him, adored him. I guess I was influenced in some way. And again I'm very interested in Beckmann. Max Beckmann. He's

made a place, and it's very important to make a place.

Things are in my mind. My mind's going faster than my mouth, so I don't know what to say.

AUD: *[inaudible]*

PG: Figures, yeah. It's the same guy. Like Kitaj said, it's a personage. And without him, I couldn't . . . I mean, he triggers everything off. You know, you can only go by feeling. All I know is, when I leave the studio, which is about fifty feet away from the house, and one of these comes off, I like the feeling that I don't have a painting in there, I've got a being in there. He's there. Or another guy is in there. A duplicate. One of the greatest things that was said in recent years was Giacometti's statement that he wants to make a duplicate. The idea of a duplicate is just fascinating. So the guy is in there, he's in bed, he's thinking. It's like making a golem. You know what a golem is? The medieval rabbis made a golem. It's impossible. Only God can make life. A golem was like Dr Frankenstein.

So I went to Italy, after not being there for some time, and I saw all the paintings I love differently, you know? They all made golems. They made an imaginary world of golems. And that's really very exciting in painting, to make a duplicate of the

world. Not a duplicate, of course. There's a paradox there. It goes parallel to the real world. And that's a key word, *parallel*. But it's a different world. And that's very exciting to me.

AUD: Do you think you were doing that all along without realizing?

PG: Yeah, I thought a lot about that. And it's very funny to think about yourself over a span of years or decades. It's hard to think clearly about it, because at a certain point it boggles the mind. How do you know? I don't know. But you only know now, really. And it's all relative, too. Because where you are now colors your looking. It's like a movie going backwards. So all I know is, I like tangibilia. I just like things touchable. Like you could bump into it.

AUD: *[inaudible]*

PG: I don't want to dream. I think painting is a dream, but it should be like a dream with eyes open fully with stuff. So, early paintings of mine from the fifties, say, very spare things, if you know them – I look at them very much like an old girlfriend or an old love. I can't look at it critically. All I remember is the mood I was in when I did it. That's what I wanted to do. And this leads to a question which is very interesting to consider.

214

Let me see. How to say it? I feel like I'm giving one of those little sermonettes, you know? When the TV goes off? Here's another sermonette. Things that stay in your mind. Like the best thing that Picasso said, and he said a lot of wonderful things. He's one painter who really talked, wisely at times. He was a buffoon, too, but he said some marvelous things. I forget just how he put it, but, to paraphrase it, he said 'self-trust'. It sounds like nothing, but it's a very hard thing to achieve, for me. To trust yourself. Because we really don't do it, you know. We depend on a lot of structures outside. Teachers, books, everything. History. So, how do you trust your instincts? In other words, if you have an impulse and you make a painting, you do it. You believe in it at that moment. Now, a month later, a year later, you say, 'Well, that's not so good.' But what are you doing? Are you denying your conviction at the time you did that? And can you? Should you? You know what I'm getting at? So if I did something with this total conviction and my life depended on what I painted in 1950 and I signed the canvas, well, that's what I did at that time. Self-trust. It sounds like nothing, but . . .

AUD: *[inaudible]*

PG: Possibly. You can eliminate yourself by thinking about self-indulgence. That's right. Sure. You can become that, but then you can become anything. You can think yourself out of things. You can check and negate so much. Many times I think, 'Oh, Jesus, I'm just self-indulgent.' You tussle with that. Sure. And then you can make rationalizations, and that's no good either. I mean, at the bottom of the barrel, all you've really got is your instinct, finally. Or whatever that word means. Instinct. Urges. Loves you have. That's a big one. And the method, technique, you find it. You find the way to do it. Well, that's what I had. The fact that it looks different, that's something else. It's something we can't control. And of course the question always comes up with younger artists like yourselves. I'm forestalling the inevitable question. Maybe it's not in your mind, but I know people who say it and I know it's probably valid in many ways: At what point do you have that self-trust? I mean, conviction. In other words, should you first learn how to do such and such? What do you think about that? And then at what point do you trust this thing? I don't know how to answer that. I think that, coming back to yourselves, well, I'm part of it too. Because I think that that area of

trusting urges and instincts, I mean, who says? You go out and paint a landscape and there it is – the tree, the sky, the sea, the cow, whatever. Nobody's telling you to put the blue here, put the green there. At some point you've got to mix up the stuff and put it on, no? I mean, that's what you're doing. There are no rules. You learn after the stuff is on there. But I would maintain that the other thing I'm talking about is just as much a part of your painting as analyzing it and talking to your teacher. You know what I mean?

So, we're all students, and I mean that. I don't mean to sound modest, but I study my books and I go to museums and I look at Rembrandt. I look at a Goya and I look at Chardin still lifes, and I think it's a miracle. And I think about it, it's on my mind. And then there are times when I don't want to. Like, for years I won't go to a gallery, I won't go to a museum. I won't look at another painting. I can't. So you do both. I think I mainly go to museums. Well, galleries – who goes to galleries? You go to museums. And you look at the masters, that's who you look at. And you learn. And then you see them differently all the time. That's a great thing, to see them differently. Maybe not better but differently. What can you do?

CONVERSATION WITH HAROLD ROSENBERG
1974

HAROLD ROSENBERG: Philip, the big problem of your painting as far as the public ... Well, we don't know what the public thinks, but as far as the reviewers are concerned, the big problem is the paintings' appearance of crudeness. They look as if they were all bashed up. Now, do you regard that crudeness as a positive quality or as a sign of indifference to qualities which are usually tempting to be dealt with in a finished way?

PHILIP GUSTON: The only answer I can think of is that years ago it was reversed. In the fifties, when I was doing certain pink pictures, people would talk about a certain beauty, how seductive they were. It was thought they weren't crude, you see. And speaking of whether I had planned this beauty, I remember in the late fifties when the work started getting blockier and heavier, John Cage, who liked the work of the early fifties, was very upset, and he said, 'How could you leave

that beautiful land?' I mean, it *was* a beautiful land but I left it. I don't think about beauty anyway. I don't know what the word is. But, no, I don't plan the crudeness.

HR: But is it a negative thing? Is it that you just don't care about beauty, let's put it that way, or that you want the positive? I guess you've answered the question. In other words, you're not interested in an effect, and it's not simply that you've abandoned the land of beauty.

PG: Exactly. So that when the brush finally goes where it's supposed to go, where it's destined to go, that's it. Some months ago, a university here asked me to come and give a slide talk on my work, saying that the faculty and students would be most interested in hearing me explain why and how I moved from abstract painting to figurative painting. I declined and giggled to myself when I read the letter, because in the late forties and early fifties I would get invitations to come and give a slide talk and explain why and how I changed from figurative to abstract painting. So you can't win. I mean, it's impossible to explain.

HR: You can't win, but you can keep on talking.

PG: No, you can keep on painting.

HR: Let's start with the idea that you don't care anything about beauty. But I've noticed that the composition of these paintings is quite careful, even impressively well balanced. For example, these two smaller paintings called *Smoking I* and *Smoking II* . . .

PG: Yes, two heads.

HR: . . . are beautifully composed paintings, if you got rid of those scrawly lines in the figures. The blocks of color . . .

PG: I don't believe that. For whom?

HR: For the people who like beautiful paintings.

PG: Oh, I see.

HR: I don't think that you could say that those are careless or self-developed compositions. Or is that just a habit you can't get rid of?

PG: Well, that could be. They're bound to turn into a painting.

HR: That's a problem.

PG: Sure.

HR: What can you do to prevent yourself from doing a good painting?

PG: Well, you don't start out wanting to do a good painting.

HR: All right, let's start from there. You don't start out wanting to.

PG: No. God knows where you start and how you start. Every painter and writer knows there are private strategies, as Cocteau calls them, 'professional secrets'. Sometimes in painting I keep making 'mistakes', then I realize that what's happening is that I keep scraping out the mistake because it's not meeting certain expectations that I have developed from the last painting, and then I reach a point where I follow the mistake. I mean, the hand wants to go to the left instead of to the right. So at a certain point I become willing to follow and see where going to the left leads, and it leads to all sorts of detours, fascinating detours.

HR: Philip, when you say 'a mistake', don't you really mean something that . . .

PG: Not meeting expectations, really.

HR: Or maybe meeting them. It could be both.

PG: It could be. Yes, you're right.

HR: It could be that it looks too much like what you thought it would be.

PG: Sure. Well, you said something at lunch which interested me. As we were talking about critics, you said that a certain critic of the *New York Times* likes the kind of art . . . how'd you say it?

HR: He likes art that looks like something that he knows, but not quite.

PG: Yes.

HR: If you want to become a critic for the *New York Times*, the formula is: you're really interested in the depiction of appearances, but you know that the camera does that. So you say, 'Well, I don't want naturalistic painting, I want a painting that looks like, say, Central Park, but it doesn't quite look like it. So I know that the temperament of an artist has changed the way it looks to the ordinary visitor to Central Park.' Then you know that you have a real work of art.

PG: I didn't have a sense of that. I just thought it was an interesting point. You wrote down some other notes. I'm curious to know . . .

HR: Well, I wrote down three things. One was the question about the crudeness, whether it's positive or negative. We have decided that point. It's negative. That is to say, it's not intended to create an effect of crudeness. It's just indifference to what is normally considered to be beauty.

PG: Now, in fact, in 1965 when we made that dialogue for the Jewish Museum exhibition catalog, somewhat the same question came up. Not in the same format, but I brought up the subject towards the end of that conversation which I thought was a crucial one and I still do, that perhaps part of

my process of working is almost to pretend. But, you know, pretense becomes real after a while, and then I'm really in it, and there is no way back. I would imagine what it would be like to paint as if there had never been any painting before. Now, that's an impossibility. Naturally I'm very involved with the culture of painting. Nevertheless, getting involved in the painting means to divest myself continuously of what I already know, and this gets you into an area of, well, you call it crudeness, but at that point it's not crude to me. I just want to realize a certain subject.

HR: But the concept of crudeness comes up, for example, most perfectly when we talk about folk art. It looks crude but it has certain qualities. That's the way people who are pro folk art talk about it. The idea is that somebody has a strong feeling but he really doesn't know how to paint, so he makes a terrific painting, only it's crude and it's technically inept.

AUDIENCE: This is highly sophisticated, so what are you talking about? It's really obvious that it's highly sophisticated, so what's all this 'crude' bullshit? It's a highly sophisticated development. It's very obvious that the whole history of painting is contained therein, so what's all this business

about being crude? What is it, a sack of bananas or something?

HR: That sounded very aggressive and passionate. It sounded crude. Now, in folk art there is the concept of crudeness, but the idea is only based on the antithesis of academic painting. When you're talking about getting to paint like the first person, this is of course a highly sophisticated idea, as when Mallarmé said that the poet is an Edenic person, one that comes out of Eden. The concept is one of freshness, and of course that's what we like about folk art, that it's fresh.

PG: But that's what we like about some of the modern masters, too. Picasso and Matisse and Léger.

HR: And Cézanne too, even. That is, the idea of freshness is one of the great values in what's called modern art. So in that sense there is no art. Baudelaire, in fact, made a great distinction between a painting that's complete and a painting that's finished. A painting that's complete can have all kinds of empty spaces around it. A painting that's finished has been tickled to the point where it begins to look like it belongs in a museum, and I think that's relevant to what you're talking about. Actually, if you feel like drawing the line thickly without modulation, it's a choice

that is absolutely as legitimate as any other choice.

PG: Sure, but as a choice it's not that I don't think ahead. It's that it's not even a choice. That is to say, I'm at a point where I literally can't do anything else. There's no choice. You've been driven to that point. What was once a choice is no more a choice.

HR: I think John Cage suggested that you could prevent yourself from being driven.

PG: That's what my story meant.

HR: He said you could *not* be driven.

PG: That's right. That you could choose.

HR: You made a mistake.

PG: I made a choice.

HR: You made a choice.

PG: But I chose.

HR: Of course, if you can't choose, you can't make a mistake.

PG: That's right.

HR: You're a victim of mysterious forces.

PG: That's part of the joy.

HR: You want to be a victim of mysterious forces? You want to choose or not to choose?

PG: I hope to be a victim.

HR: You want to be a victim?

PG: Yes, very much. In fact, it's very difficult to become one. You really have to prepare for that state. Oh, yes. Were you asking me that, thinking I would say no? You know I would say yes.

HR: No. Well, I thought you'd also put something else in.

PG: Oh, I see. Any victim that decides to . . .

HR: It's really sublime to think that all you can be is the victim of a sublime executioner. You want to be executed by something.

PG: I don't want to be executed. Just so I can continue being a victim.

HR: We discussed the fact that each time you wanted to be as if you were starting from scratch, like the first man.

PG: That's what I meant, yes.

HR: The Edenic poet. But then how come your paintings look very much alike? You want to start all over again each time as if you were just born and it so happened each time that Guston was born he looked like a Guston who just died!

PG: I don't think so. To be changed each time may be a necessary illusion that we permit ourselves.

HR: I know every time I write something, I feel as if I've gotten into new ground. At least I find myself as completely confused by it as the first piece I

ever wrote. And when I'm finished with it, it sounds just like the last piece I wrote. I don't think it's an illusion. I think it's a condition.

PG: What I mean by this illusion is that when you are in the work, you think you're making a leap, but in truth you may be only, say, an inchworm.

HR: If you're lucky!

PG: If you're lucky. And we really move in time very slowly. Although in the heat of it we have illusions, which comes from the fact that one picture evolves from the one before. A chain. Otherwise I'd be like someone throwing out a lasso. I don't throw out a rope for a hundred yards and follow it.

HR: Why not?

PG: I seem to be more conservative.

HR: One thing at a time.

PG: It could be a question of personality. At times when I have gone way out, I find I need to come back for that inch.

HR: There was a mystical rabbi who said that a saint was like a thief. He's always active in the middle of the night, and he risks his life for small gain.

PG: When a show is put up, when it gets out of the studio and I see the work on the walls, I have an uncanny feeling that somebody, I don't know

who, is writing the plot here. Somebody is plotting this, you know.

HR: You mean it was inevitable that you should have done that? You are caught in – what shall we say? – a destiny.

PG: Well, that's making it sound very . . .

HR: Well, a plot is a destiny. I mean, somebody has it written in his brain.

PG: Written, yes.

HR: Well, that's what you meant before, when you said you couldn't have done anything else.

PG: That's right. I don't have a feeling when I'm painting that I'm just plugging in the holes.

HR: But that's what you mean by the mistakes too, that it's just a plot.

PG: But the real subject would include the paintings, the images, I've destroyed. The manuscripts you've destroyed. It would be fascinating to talk about what one destroys. It fascinates me, destroying my images. I remember them just as well, sometimes more, than what stays. They no longer exist, but they exist in my mind. So I remember them. They're as concrete as the pictures that remain.

HR: The pictures that remain are related to one another, but would you say that about the ones

you've destroyed? You could say that, if you had a record of those non-paintings, they could have a similar relation to one another.

PG: I can be very specific. Some of the images I'm painting now I painted and destroyed ten, fifteen years ago, yes. Absolutely. I don't have a photographic record, but I just know that that is true. So it's a question of time: being ready, you might say, to accept.

HR: Well, that's not so uncommon. I have, for example, a painting, an ink drawing by de Kooning, which he did in 1948 and which he gave me at the time. Then about seven or eight years later, there began to appear some spots.

PG: What were the spots?

HR: The drawing was done on a thin show cardboard with ruled squares. The spots began to appear and somebody thought that maybe the paper backing had oil on it. Anyway, we took the frame off and there was an oil painting on the back of the board, which de Kooning had obviously discarded. It looked like work he did fifteen or twenty years later, though different too, of course.

PG: One is never finished with anything.

HR: No, it circles back.

PG: Yes. In fact, some of the new paintings are close to the work of the 1930s. One is never through with that.

HR: Let me ask you this: Do you feel that, working now, there is a difference in the degree of freedom, of spontaneity, from those paintings of yours in the fifties?

PG: Yes.

HR: Very spontaneous? A fresh quality? These paintings look more composed, have preconceived themes.

PG: Well, some of them are . . .

HR: Executed. On the other hand, I don't think they're necessarily less free and spontaneous. What do you think?

PG: Well, as you know, in the early fifties I became very involved in discovering painting as you paint, and this was pretty constant with me over the years. Now, in the last six to eight years of painting, I felt like reversing the process. I made drawings for weeks before I started to paint. Why? Well, I felt like it, for one thing. I wanted to see if I could do it.

HR: You mean, if you could work out a composition completely.

PG: No. The idea, rather. Well, it wasn't so much the composition but the forms, the subject content of

it, the images. I saw the picture in my mind or in drawings that I made before I painted, and the painting usually went very fast with very few changes. It was fascinating to me to do that. But not exclusively so, either. I think that what I've done, I hope, is widen my range. I still will start paintings without drawings and very little pre-conception. I mean, I know I'm going to have a man lying in bed. I know I'm not going to have three elephants walking there. I know roughly what I'm going to do, but I'll start and just plunge in and paint and keep changing areas that need changes. So I do both. It's satisfying to me to know that I can have this range, to not be so exclusively . . .

HR: Spontaneous?

PG: Spontaneous. But that's an esoteric obstacle for me. I don't know what spontaneity means, whether it really exists.

HR: Apparently, Jackson Pollock felt that the fact that he did not make sketches was a central aspect of his work, that it came into being in the course of trying to paint. You don't think of it that way?

PG: No, it's too simplified a version of the whole thing. I mean, I think that Pollock was essential, that he did what he did. Every painter does what

he does, invents his own technique, so to speak, or method. What he claimed may be his rationalization of it. It may also indicate his own personal struggle, anti-Renaissance. In a sense, Jack came out of late Renaissance painting. I think his early paintings are descendants of El Greco. To speak of spontaneity is too simplified a version. When you study Renaissance painting, you can find anything you want to find. You find blotches and spontaneity and spots, especially in drawings, and you can find preconception and years of preparation for a single canvas.

AUD: You've been talking about crudeness. What do you mean by that?

HR: Well, look at the show* afterwards. That's the best reply, because you'll see that the contours and the way it's painted show no great interest in a finished or elegant canvas. What's the opposite of crude?

AUD: Refinement.

HR: All right. These paintings are not very refined.

AUD: Are you talking about the paintings or are you talking about the subject?

* *Philip Guston: New Paintings*, Boston University School of Fine and Applied Arts Gallery, March 15–April 14, 1974.

HR: I'm talking about the handling. That is, the form, the way details are treated. For example, there are plates of French fried potatoes that really don't look like a good . . .

PG: Meal.

HR: Well, a good ad. I mean, you'll never sell any French fries. They wouldn't give you an appetite for French fried potatoes. They might give you an appetite for paintings.

AUD: Are you trying to say that what you mean by crudeness is vitality? Are you trying to say the paintings have vitality? Is that what you're talking about?

HR: What's vitality?

AUD: I'm trying to say: Do the paintings have vitality?

HR: *Crudeness* is not a synonym for *vitality*. I think it would be nice if you talked about some of the imagery in your paintings. Like pairs of shoes, French fried potatoes, lightbulbs.

PG: Well, there isn't really a hell of a lot to say about that.

HR: You have recumbent men. I didn't notice any ladies. Also soles of shoes. I want to talk about those images. Why are they recurrent?

PG: That's a tough one. I don't know. What would you say about that?

HR: Are they unconscious? Of course, you did have some of them a long time ago, but also in your last show.

PG: Oh, yes.

HR: You must have some feelings about the use of those lightbulbs.

PG: I'm painting, I'm using tangible objects, obviously.

HR: But why those?

PG: Why those? You mean, why not, why don't I . . .

HR: I mean, you could have a horse instead of an automobile.

PG: No.

HR: As a matter of fact, in this show you have no automobiles. In the last show you had a lot of automobiles. Automobiles are going, aren't they?

PG: Well, the figures are inside, not riding around. They're in bed.

HR: No, but you have some landscapes.

PG: I don't know. I think what I can say is that six or seven years ago I began painting single objects that were around me. I read, so I painted books, lots of books. I must have painted almost a hundred

paintings of books. It's such a simple object, you know, a book. An open book, a couple of books, one book on top of another book. It's what's around you. On the kitchen table there's a lamp. I don't have that kind of lightbulb, but somehow that lightbulb recalls something to me. There's something about a naked lightbulb. Why, I don't know. If I talk too much about it I'll stop using it.

HR: You want to continue using it?

PG: No, I don't know whether I want to continue using it. I don't know what I'll do, but I do know that I enjoy the idea of unexotic objects. I like banal, simple objects, tangible, touchable. I'm doing a painting and my shoes are on the floor. Man is upright, he walks, he needs shoes. What else do you paint? I don't paint stripes. But I don't think shoes are better than stripes.

AUD: I'd like to speak to Mr Guston. You had a painting exhibition at the school and it was mostly Ku Klux Klansmen. For the past few years, you've been working mostly with Ku Klux Klansmen. I notice that in the paintings here you're working with a new image of the sleeping figure. I was just wondering what you foresee about this image as an image. Are you going to explore it as you did the Klansmen?

PG: Yes, they're really very recent, these recumbent figures. Actually, I think of them as the painter in bed. One of them, the one with the French fries, is called *Painting, Smoking, Eating*. Paint cans on his chest, imagining a painting above him. Thinking now about them, they are mostly about painting. They're paintings about the painter. In the paintings of 1968–70 I also made the hoods into painters. There were pictures where the hoods became artists. My favorite group, the ones I keep, that I find I take out and look at, enjoy the most, are where they are painters. I took one down the other day to show to someone who hadn't seen the work, and I found the first picture I pulled out was where the hooded figure is painting another hood. I also had them discussing art, become art critics. I had one looking at an abstract painting.

HR: Are there any where you think of a left political show?

PG: No, I'm not that interested in a direct political interpretation.

HR: But you are interested in politics.

PG: Sure. Everybody's interested in politics.

HR: In the last show, I mean, the political experience, I remember you talked about it a lot.

PG: Yes, I was very influenced by what was happening, when the hoods were doing things, beating people there, tying up bodies, patrolling, driving around cities. But now I think they're thinking about it. Now they're more meditative about the whole thing. Reflective.

HR: That's why they're lying down.

PG: That's a good statement of reflection, yes.

HR: They're not riding around in an automobile.

PG: It'd be silly to have them . . . I would no more put them in a car now, there would be no reason.

HR: So you think times have gotten more peaceful.

PG: Oh, no. Peaceful? No.

HR: Well, the people aren't running around piling up bodies.

PG: No. Well, I was never concerned about illustrating it anyway. I wanted to go deeper into meanings and overtones. Now they're thinking about it all. It's more inside. I have to dig for the images that come out.

STUDIO NOTES*
1970–78

* Guston kept a pad of yellow legal sheets in his studio roll-top desk, on which he penciled notes to himself, ideas for pictures, letters, and sometimes sketched images for later development. The present selection of those writings was made by Musa Mayer during research for her book *Night Studio*.

September 1970

In a drawer I find scraps of paper with these notes.
Thickness of things. Shoes. Rusted iron. Mended
rags. Seams. Dried bloodstains. Pink paint. Bricks.
Bent nails and pieces of wood. Brick walls. Cigar-
ette butts. Smoking. Empty booze bottles.

How would bricks look flying in the air – fixed
in their gravity – falling? A brick fight.

Pictures hanging on nails in walls. The hands of
clocks. Green window shades. Two or three-story
brick buildings. Endless black windows. Empty
streets.

'About these hooded men.' The KKK has haunted me since I was a boy in L.A. In those years, they were there mostly to break strikes, and I drew and painted pictures of conspiracies and floggings, cruelty and evil.

Also, I made a connection with my attraction to medieval and Renaissance paintings, the flagellation pictures of Piero, Giotto, and Duccio. Violence in a formal painting.

In this dream of violence, I feel like Isaac Babel with his Cossacks; as if I were living with the Klan.

What do they do afterwards? Or before? Smoke, drink, sit around their rooms (lightbulbs, furniture, wooden floors), patrol empty streets; dumb, melancholy, guilty, fearful, remorseful, reassuring one another?

Why couldn't some be artists and paint one another? Soon I'll paint a picture of some of them eating around a table (great chance to paint food: spaghetti, hamburgers, beer, etc.). I tried one last year of two of them shaking hands. It didn't work out – yet.

Pictures should tell stories. It is what makes me want to paint. To see, in a painting, what one has always wanted to see, but hasn't, until now. For the first time.

Philip Guston, *Web*, 1975. Ink on paper. 18½ × 23½ inches.
Private collection.

September 28, 1972

There is nothing to do now but paint my life; my dreams, surroundings, predicament, desperation, Musa – love, need. Keep destroying any attempt to paint pictures, or think about art.

If someone bursts out laughing in front of my painting, that is exactly what I want and expect.

From a note to Dore Ashton on the draft of *Yes, But . . .*

In general, I feel I am always described as in trouble and in crisis. Most artists feel that way. But when the picture comes out there's a calm and feeling of continuity. I think the frequent use of *crisis* and *anxiety* gives the impression that I am in constant pain. As it feels to me, when the picture takes form, the new structure itself calms me and I would hope that the looker does not feel he is looking at pain, trouble, and anxiety, but at a new structure which he can contemplate. Ideally! That he gets a real, positive change.

Years later, discussing my work with Clark Coolidge, we used to talk a lot about Melville. One story Clark told me stays in my mind: Melville is writing to Hawthorne after having finished *Moby Dick*. He says, 'I've written an evil book and I feel spotless as a lamb.'

Oh, how I hate the calculation, the reasoning of the eye and mind. I hate the composing – the designing of spaces – to make things fit! What, after all, does it satisfy? It robs and steals from the image that the spirit so desperately desires.

But I love the shadows, for themselves alone.

My wife Musa once wrote, 'Because the sun was behind them, their shadows came first, and then the birds themselves.'

The Law

The Laws of Art are generous laws. They are not definable because they are not fixed. These Laws are revealed to the Artist during creation and cannot be given to him. They are not knowable. A work cannot begin with these Laws as in a diagram.

They can only be sensed as the work unfolds. When the forms and spaces move toward their destined positions, the artist is then permitted to become a victim of these Laws, the prepared and innocent accomplice for the completion of the work.

His mind and spirit, his eyes, have matured and changed to a degree where knowing and not knowing become a single act.

It is as if these Governing Laws of Art manifest themselves through him.

Thoughts (or Advice to Myself)

Sunday, September 27, 1978

I just did a painting which I shall call *The Tomb* or *The Artist's Tomb*. So it is truly a bitter comedy that is being played out. Painting, which duplicates and is a kind of substitute for your life, is lived from hour to hour, day to day. Nothing is stable, all is shifting, changing. There is no such thing as a picture, it is an impossibility and a mirage to believe so. A fantasy the mind makes like having a dogma, a belief. But it won't stay still, remain docile; you can't tame anything into docility, with yourself as the master. Being a lion tamer – that's just circus razzle-dazzle.

Sometimes I spread out all over the canvas, the rectangle of action, and make this unstable and precarious momentary balanced-unbalanced condition. I did this last week. Now, in reverse, yesterday and today, I made a rock, with platforms, steps for my forms to be on, and play out their private drama.

This will remain for a while.

Untitled, 1980. Ink on paper. 18¾ × 26⅜ inches. Private collection, New York.

The only thing I have is my radicalism against art. All that abstract shit – museum and art history aesthetics.

What a lie – lie!

The only true impulse is realism. Arty art screws you in the end; always be on guard against it!

If I speak of having a subject to paint, I mean there is a forgotten place of beings and things, which I need to remember. I want to see this place.

I paint what I want to see.

The Appointment (A True Story)

Once there were two Philips who were friends. One was a very famous writer, a celebrity, the other a painter who had some degree of fame. Philip the Painter, who lived in the mountains and whose solitude was always being interrupted by the telephone, decided to put a stop to this thievery of time. He installed a switch that turns off the ringing telephone. This was a luxurious feeling for him, since he could telephone out to the outside world, but the outside world could not reach him at all.

Philip the Writer, who lived in the City (by preference, he once said, where he could roam the streets at will, eat in foreign restaurants, and taste all sorts of imported delicacies), had been trying to telephone Philip the Painter for six months. Then, after a trip to European cities, Philip the Writer tried again to telephone Philip the Painter. Again without success. Finally, Philip the Writer wrote this letter: 'For Christ's sake let your phone ring. The world isn't just shit heads and monsters wanting to disturb you at your sacred foolishness – there's also me, your old pen and brush pal. Call me.'

Philip the Painter waited a week before he telephoned Philip the Writer, whose answering service said he was busy and that he would telephone Philip the Painter. But remember, Philip the Painter's telephone couldn't ring, and since he again went back to his 'sacred foolishness' in his studio, weeks went by. He received a second letter from Philip the Writer. This time in capital letters. 'HOW CAN I CALL YOU BACK IF YOU WON'T ANSWER THE TELEPHONE? HUMANLY IMPOSSIBLE. TECHNOLOGICALLY IMPOSSIBLE. HOPELESS SITUATION, NO?' Then, as if they were secret agents, a designated time was chosen (through a third party, a neighbor) for Philip the Painter to telephone Philip the Writer. Philip the Writer couldn't believe his ears when Philip the Painter called. Philip the Writer pretended he wasn't home when he answered the phone call.

The dilemma was overcome when Philip the Writer agreed to visit Philip the Painter a week later for dinner and some talk. With the stern admonition, however, that since Philip the Writer couldn't telephone Philip the Painter, the appointment had to be firm and definite. This appointment made Philip the Painter more nervous than usual. He never knew from minute to minute how he felt. He

couldn't control his moods, which changed like the shape of clouds. The commitment to a definite time of meeting might mean that he would have to telephone Philip the Writer again in order to change the time of the meeting to a future time. Naturally, this made him even more nervous.

This story ends happily, however.

Through a new source of willpower, Philip the Painter overcame his nervousness and was calm as he prepared to entertain his friend, Philip the Writer. This determination was accomplished by the feeling of security that they would spend their evening, during and after dinner, leisurely discussing their mutual nervousness about the time stolen from their work by the world outside. He knew they would exchange their fears of the ringing telephone. Philip the Painter knew that he and Philip the Writer would speak of their miseries and would plan strategies to prevent the frightening theft of time.

There is *no* [underlined three times] relationship between my desires, ambitions, and the needs of a dealer!

The total conformity of painting now that we see is absolutely deadening to my spirits. Its conventionality. Its domesticity.

De Chirico's thought was not willed. It was so perfectly balanced that his forms never seem to have been painted. His walls and shadows, his trains and cookies, his manikins, clocks, blackboards, and smoke. They could all disappear. Yet they appeared. They have known each other for centuries. De Chirico drew aside his curtain, revealing what was always there. It had been forgotten.

Picasso, the builder, re-peopled the earth – inventing new beings. We believe his will.

Marvelous artists are made of elements which cannot be identified. The alchemy is complete. Their work is strange, and will never become familiar.

You can wreck your painting that you believe in by overexamining it – dispel its magic – its spell lost.

Advice to myself: leave it alone.

It should be able to live by itself.

November 23, 1978

When I complete a painting that feels real – I think afterwards that I have found a way – a road. And my mind races on – painting pictures in my head. Infinite possibilities. What a delusion this is. All the possibilities – oh, at last I know. These are mere notions – proven to be so when you start painting again. They all tumble down when paint is put on. And again you must learn that there is no road – no way – all you possess is the luck to learn to see each time – freshly. Newly.

No good to paint in the head – what happens is what happens when you put the paint down – you can only hope that you are alert – ready – to see. What joy it is for paint to become a thing – a being. Believe in this miracle – it is your only hope. To will this transformation is not possible. Only a slow maturation can prepare the hand and eye to become quicker than ever. Ideas about art don't matter. They collapse anyway in front of the painting.

December 8, 1978

American abstract art is a lie, a sham, a cover-up for a poverty of spirit. A mask to mask the fear to reveal oneself. A lie to cover up how bad one can be. Unwilling to show this badness, this rawness. It is laughable this lie. Anything but this! What a sham! 'Abstract' art hides it, hides the lie, a *fake!* Don't! Let it show! It is an escape – from the true feelings we have – the 'raw' – the primitive feelings about the world – and us in it. In America.

'It' is a game, as if we are all on a softball team on the backyard lot. We all agree, don't we? On the game rules – 'Play Ball'. Fit into the crappy lie of advertising art. Fit into the scheme of everything – don't make waves – be a good boy – live and let live – what shit this is!

Where are the wooden floors – the lightbulbs – the cigarette smoke – where are the brick walls – where is what we feel – without notions – ideas – good intentions? – No, just conform to the banks – the plazas – monuments to the people who own this country – give everyone the soothing lullaby of 'art'.

We all know what this is – don't we?

A painting feels lived-out to me, not painted. That's why one is changed by painting. In a rare magical moment, I never feel myself to be more than a trusting accomplice. So the paintings aren't pictures, but evidences – maybe documents, along the road you have not chosen, but are on nevertheless.

New Paintings

A figure lying in bed, very still, looking at a ball stopped in front of his nose, yet everything around him, windows, boxes, toys, books, are in motion. This just got itself painted.

A pile of junk between two telephone poles. The itch to kick it, disperse it.

I really only love strangeness. But here is another pileup of old shoes and rags, in a corner of a brick wall – in front, a sidewalk. I've been there. I've seen it before, but forgot.

Green shade above with a chain to pull. Light it up.

Large wall, a picture, a window. A hanging lightbulb. Not much else. Forms painted out.

Back view, lying in bed, smoking.

A head, profile, vomiting out forms or sucking them back in.

A desolate hill, littered. Forms that got on top of that slope might move on to the other side and be invisible.

The sun coming up has moved its position on the canvas many times from left to right and back

again. Finally, towards dawn, it fixed itself. A very heavy sunrise.

H. Michaux:

The two brothers fighting in mud.* I want to paint that.

* Henri Michaux, 'In the Land of the Hacs' [Chez le Hacs], in *Selected Writings* (New York: New Directions Books, 1968), 133.

Images

Afternoon.
Mended rags.
Clock-face.
Sticks of wood behind
a brick wall. Graining.
Back yards.
screen doors.
porches.
old cars being dismantled.
Venice, Calif.

Reminders

The thickness of things.
The object painted on a store window. A shoe –
a book – to be seen instantly from a distance.
The worst thing in the world
Is to look at another painting.
Make your mind blank and try
To duplicate the object.
The images I've painted out.

One morning, disconsolate, I started to paint,
not watching myself.
A sense that I am painting in reverse.
I continue the mistake. In the end,
there is the image I have been wanting to see.

Thank God for yellow ochre, cadmium red
* medium,*
and permanent green light.

Where I Paint

The studio is an empty room and has a wooden
 floor.
It is three flights up in a red brick building.
The window is open. There is no sound and the
 early
sky is pale blue. I look out to see the end of the
street, the edge of town.

A party is going on in a large room. In a remote
corner I am painting on huge sheets of wrapping
paper. I concentrate on what has to be done and
soon I am finished.

ACKNOWLEDGEMENTS

With appreciation to The Guston Foundation (PhilipGuston.org).

Interview with David Sylvester

First published in *Interviews with American Artists*, ed. David Sylvester (New Haven: Yale University Press, 2001), 85–98. Copyright © The David Sylvester Literary Trust. The interview was recorded in March 1960 for broadcast by the BBC.

Piero della Francesca: The Impossibility of Painting

First published in *Art News*, May 1965, 38–9. Copyright © 1965 ARTnews, LLC.

Faith, Hope, and Impossibility

First published in *Art News Annual* 31 (1965/66), 101–3, 152–3. Copyright © ARTnews, LLC. This article was based on notes for a lecture at the New York Studio School in May 1965.

On Morton Feldman

On Piero della Francesca

Talk at Yale Summer School of Music and Art

Conversation with Clark Coolidge

First published in *Philip Guston: Collected Writings, Lectures, and Conversations*, ed. Clark Coolidge (Berkeley: University of California Press, 2011), 184–211. Copyright © The Estate of Philip Guston. This conversation took place in Woodstock, New York, on 8 December 1972.

Ten Drawings

First published in *Boston University Journal*, 21 (Fall 1973).

On Drawing

First published in *Philip Guston: Collected Writings, Lectures, and Conversations*, ed. Clark Coolidge (Berkeley: University of California Press, 2011), 253–68. Copyright © The Estate of Philip Guston. This talk took place at the Yale Summer School of Music and Art in Norfolk, Connecticut, in July 1974.

Conversation with Harold Rosenberg

First published in *Boston University Journal*, 22, no. 3 (Fall 1974), 43–58. The conversation took place at

the Boston University School of Fine and Applied Arts and was transcribed by Ruth Lepson.

Studio Notes (1970–78)

First published in *Philip Guston: Collected Writings, Lectures, and Conversations*, ed. Clark Coolidge (Berkeley: University of California Press, 2011), 308–16. Copyright © The Estate of Philip Guston, with the exception of 'Reminders' and 'Where I Paint', which were published in Bill Berkson's *Big Sky* magazine, no. 6 (1973).